IMAGES
of America

LOS ANGELES'S LITTLE TOKYO

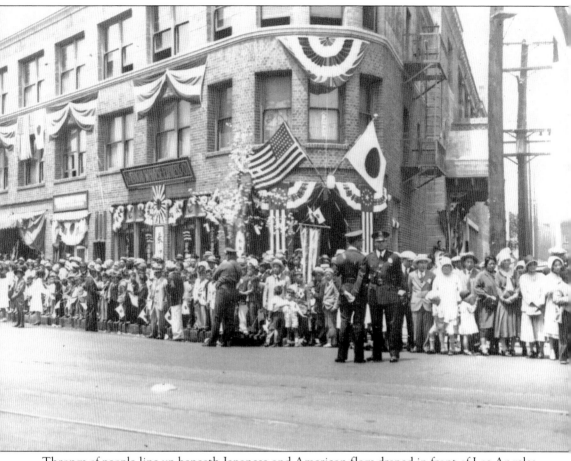

Throngs of people line up beneath Japanese and American flags draped in front of Los Angeles Hompa Hongwanji Buddhist Temple at First Street and Central Avenue for the parade honoring visiting royalty, Prince Takamatsu, the younger brother of Japanese emperor Hirohito, in 1931. Ironically Prince Takamatsu was wary of both Japanese colonial expansion in Asia and war with the United States. (Photograph by Toyo Miyatake, courtesy of Toyo Miyatake Studio.)

ON THE COVER: The Koyasan Buddhist Temple's dedication celebration was a two-day event on October 26 and 27, 1940. Two hundred *ochigo-san* ("celestial" children), the Koyasan Boy Scout Troop No. 379 Drum and Bugle Corps, and various priests from Japan and Southern California circled the heart of Little Tokyo to officially open the new temple at 342 East First Street. (Courtesy of the Takahashi Family, from the Abbot Seytsu Takahashi Collection.)

IMAGES of America
LOS ANGELES'S LITTLE TOKYO

Little Tokyo Historical Society

Copyright © 2010 by Little Tokyo Historical Society
ISBN 978-0-7385-8146-0

Published by Arcadia Publishing
Charleston, South Carolina

Printed in the United States of America

Library of Congress Control Number: 2010928304

For all general information, please contact Arcadia Publishing:
Telephone 843-853-2070
Fax 843-853-0044
E-mail sales@arcadiapublishing.com
For customer service and orders:
Toll-Free 1-888-313-2665

Visit us on the Internet at www.arcadiapublishing.com

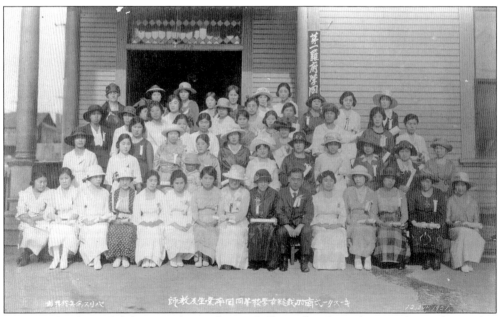

Keystone Southern California Ladies Tailoring College's fourth graduating class is depicted in this photograph dated June 12, 1921. The staff and students are standing in front of the Rafu Daiichi Gakuen (the First Japanese Language School of Los Angeles) located at 318 Hewitt Street. (Photograph by Paris Studio, courtesy of Marie Masumoto.)

Contents

Acknowledgments		6
Introduction		7
1.	Enterprise	9
2.	Traditions	41
3.	Community	57
4.	War	79
5.	Sports	93
6.	Creativity	105

Acknowledgments

The Little Tokyo Historical Society Book Committee thanks all of the donors who generously shared their time, memories, photographs, and *kokoro* (heart) for Little Tokyo to this project. Donors' names are listed in the captions.

Our deep appreciation extends to Alan and Archie Miyatake of Toyo Miyatake Studio, both of whom donated many images used in this book. We also thank the Japanese American National Museum (JANM), Michael Komai of the *Rafu Shimpo*, and the Los Angeles Public Library for allowing us to use many images from their collections. We would like to acknowledge the support of the *Rafu Shimpo* staff, including Michael Hirano Culross, Nao Gunji, Gail Miyasaki, Gwen Muranaka, and Mario Reyes.

We thank Jay Ian, Jaimee Itagaki, Victor Lazo, Mike Murase, Michael Nailat, and Alvin Tenpo for use of their photographs. Thank you, also, to Nori Takatani and Brian Kito for allowing us to photograph them while they were working!

Emily Anderson, Pastors Fred and Wilma Berry of Azusa Street Mission, Raymond Chong, Carole Fujita, Mary Graybill, Kerry Cababa, Nikki Chang, Dustin Hamano, Masako Kato, Leslie Katow, Chris Komai, Jack Kunitomi, Colleen Miyano, Yuko Gabe, Glenn Gohr, Clement Hanami, Janet Hiroshima, Ko Hoshizaki, Rinban Nori Ito, Rev. Mas Kodani, Shig Kuwahara, Scott Kushigemachi, Tim Lounibos, Alan Masumoto, Eiko Masuyama, Rinban George Matsubayashi, Edward Moreno, Martha Nakagawa, Jane Nakasako, Yoko Nishimura, Mike Okamoto, Jack Pentchev, Dale Ann Sato, Lisa Sasaki, George Takahashi, Jayson Yamaguchi, and Evelyn Yoshimura all provided much appreciated help and information.

We are grateful for the resources available on the Discover Nikkei and Bronzeville—Little Tokyo, Los Angeles Web sites, as well as Ben Pease's detailed maps of prewar Little Tokyo.

Finally, we would like to thank our editor, Jerry Roberts, and editorial coordinator, Scott Davis, at Arcadia Publishing.

The LTHS Book Committee: Rosemarie Barraza, Karin Higa, Harry Honda, Simone Fujita, Yukio Kawaratani, Helen Kim, Sojin Kim, Tadashi Kowta, Deanna Matsumoto, Vicky Murakami-Tsuda, David Nagano, Frances Nakamura, Michael Okamura, Amy Phillips, Bill Shishima, Alice Tanahashi, Lisa Tanahashi, Stephanie Van, Nancy Uyemura, Patricia Wakida, and Bill Watanabe.

INTRODUCTION

In 1884, a sailor named Hamanosuke Shigeta made his way to the eastern section of downtown Los Angeles and opened Little Tokyo's first business, an American-style café. The area grew to be a vibrant enclave of Japanese Americans in the pre–World War II period, a home to African Americans during the war, and a diverse and ever-changing district in the decades that followed. Over the years, Little Tokyo has remained the cultural and symbolic home of Southern California's Japanese American community and the country's largest Japantown.

Little Tokyo's origins are full of contradictions. It developed, in part, because of discriminatory laws against Japanese Americans that limited where they could live and work. Yet the neighborhood became a dynamic economic and cultural hub. Japanese immigrants, known as the issei, established a myriad of professional services and businesses to serve fellow Japanese. At the same time, they made pioneering strides in agricultural and fishing industries that benefited the greater Los Angeles region. As immigrants set down roots, they founded churches, temples, and cultural and community associations that carried on traditions from their homeland. They also created new ones. The American-born children of immigrants, known as the nisei, established the annual Nisei Week Japanese Festival in 1934, which continues today. Sporting and cultural activities served as bridges to the greater Los Angeles area.

World War II halted Little Tokyo's rise. The unjust removal and swift incarceration of all Japanese Americans living on the West Coast left Little Tokyo an empty shell as Japanese Americans found themselves in desolate concentration camps. African Americans, who were recruited from the South to work in the wartime defense industry, settled in the neighborhood and it was rechristened Bronzeville.

After the war, the community remained resilient and Little Tokyo revived as the hub of Japanese American life. The restrictive housing covenants were lifted, enabling Japanese Americans to live and work in areas previously off limits. Little Tokyo evolved into a multicultural community, one where diverse peoples live, work, and socialize. The rich history of the enclave and its cultural legacy continue to enrich the many thriving communities who consider Little Tokyo home.

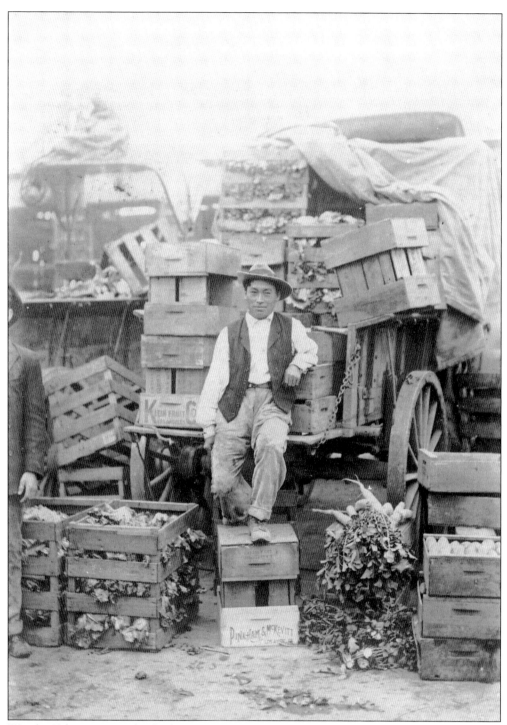

Waroku Yokota sits amidst the lettuce and daikon radishes he transported with his enterprise, Yokota Transfer Company, around 1908. Waroku and his wife, Shige, had previously operated a pig and poultry farm near Exposition Park. They later managed hotels, social dance schools, and one of the largest sewing schools in Little Tokyo. (Courtesy of Kimiko Yokota.)

One

Enterprise

The establishment of Little Tokyo may have been due to a pervading anti-Asian sentiment in the broader society, but in turn it nurtured the bonding of people who shared a common language and culture. Throughout the enclave's history, enterprising individuals made an impact on both the local and greater community.

Japanese immigrants pioneered and introduced to Southern California a myriad of industries and technologies, from vegetable and flower farming to deep-sea tuna fishing (which thrived along the West coast). Wholesale produce and floral markets served greater Los Angeles, while Japanese American importers introduced new products to market. Large brigades of Japanese men worked as seasonal and migrant farmworkers, toiling in harsh conditions. For these and others, Little Tokyo was a welcome respite and a familiar sense of home.

The necessities of daily life were provided by enterprising businesspeople who served the growing Japanese population. Individuals and families regularly made the trek from outlying areas to visit the growing enclave. All manner of shops, restaurants, churches, factories, health providers, entertainment centers, and other aspects of community life came into being to serve their diverse needs.

Now, 125 years after the opening of the first business, the community continues to thrive, full of history and a rich past, but also full of potential for progress and change. Some family businesses have operated for more than a century while others have changed and evolved. New businesses continue to be established; yogurt shops and Starbucks now mingle with sushi bars and ramen establishments.

The types of establishments are not the only difference. There are varying opinions about the exact boundaries, but everyone can agree that they have changed over time and are geographically smaller than in its heyday. Even the streets themselves have changed. Turner Street became Temple Street. Weller Street is now Onizuka Street. Jackson Street, formerly between Temple and First Streets, no longer exists. Little Tokyo's "heart" was razed in the late 1940s when the city acquired the land between Los Angeles and San Pedro Streets and between First and Market Streets to build the Police Administration Building (Parker Center). Despite the many changes, the spirit of Little Tokyo endures.

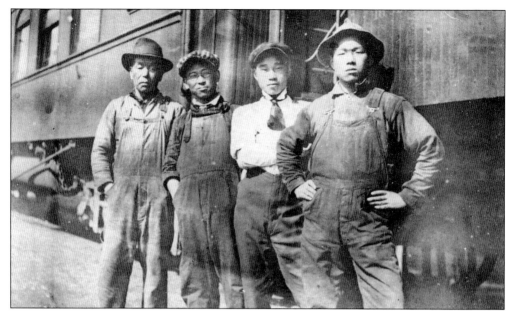

In 1885, the Santa Fe Railroad extended to the Los Angeles depot by the Los Angeles River between First and Second Streets. By 1899, both the Santa Fe Railroad and the Southern Pacific Railroad, which had reached Los Angeles by 1876, were hiring Japanese workers to maintain tracks and clean boxcars. In this undated photograph, Kyukichi Inouye is shown, second from the left, with other unidentified workers. (Courtesy of Harry Honda.)

In 1898, Sanjuro Mizuno opened the Santa Fe Hotel boardinghouse at 112 South Rose Street, catering to railroad workers and seasonal laborers. The hotel's name was later changed to the Rose Hotel around 1920. By 1908, the Japanese ran more than 90 boarding houses in Los Angeles. Mizuno later ran the Mizuno Employment Agency. (Courtesy of the *Rafu Shimpo*.)

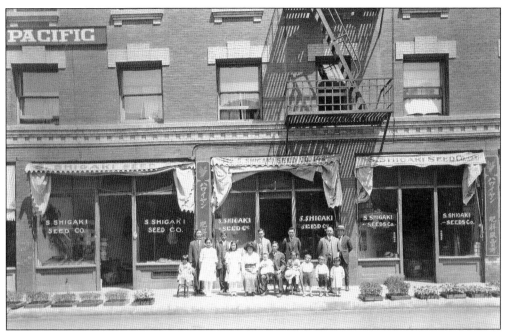

Sataro Shigaki, seated with the baby, opened S. Shigaki Seed Company at 142 South San Pedro Street in 1915. The store sold seeds, fertilizer, and plants to farmers in Imperial Valley, Oxnard, Orange County, and the San Fernando Valley. After his death at age 30, his widow, Tomi, operated the business while raising three children at their Hewitt Street home. She closed the business in 1932. (Courtesy of the Fern Shigaki family.)

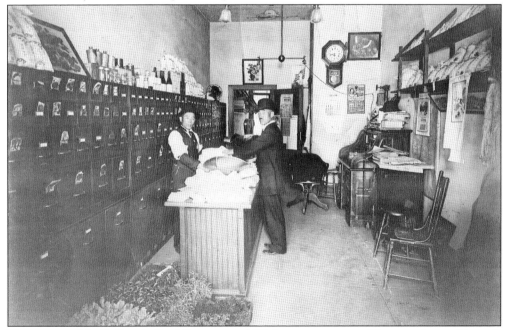

The interior of the S. Shigaki Seed Company in 1918 shows a vast array of flower and vegetable seeds and young plants available for cultivation. The business was prosperous, employing three salesmen who used a company car to travel from farm to farm. (Courtesy of the Fern Shigaki Family.)

The Japanese were highly influential in the development of both the wholesale and retail floral industries in the United States. The Southern California Flower Market, known as the "Japanese Market," opened at 421 South Los Angeles Street in January 1913. The market was later located on South Wall Street, as shown in this 1934 photograph. (Courtesy of JANM/Southern California Flower Market.)

Chiharu and Toshiyuki Okamura purchased Toyo Florist and Nursery at 113 North San Pedro Street in 1940. The sign reads "Toyo Uekiribanaten." Behind the building was a large Japanese garden and teahouse that was frequently used for poetry readings. The couple met while Chiharu attended a Little Tokyo sewing school, and Toshiyuki worked at Toyo Printing Company. They married at Union Church in 1927. (Courtesy JANM, Okamura family.)

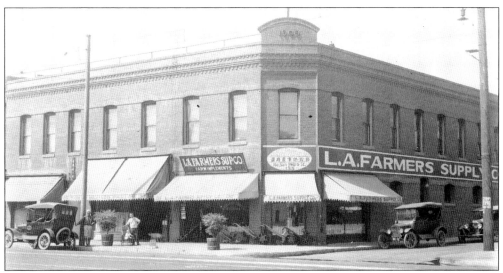

L.A. Farmers Supply Company was at 135 North San Pedro Street on the northwest corner of Jackson Street and is shown here in this *c.* 1920 photograph. It is estimated that prior to World War II, the Japanese grew and wholesaled 75 percent of all fresh produce consumed in Los Angeles. During the first decades of the 20th century, issei and nisei farmers played a major role in developing California's agriculture. (Courtesy of the *Rafu Shimpo.*)

Brothers Mataji and Isamu Rikimaru established Rikimaru Brothers Produce Company in the 1930s. The business was located at the Ninth Street Produce Market on Ninth and San Pedro Streets. (Photograph by Ninomiya, courtesy of Kazu Rikimaru and the Isamu Rikimaru family.)

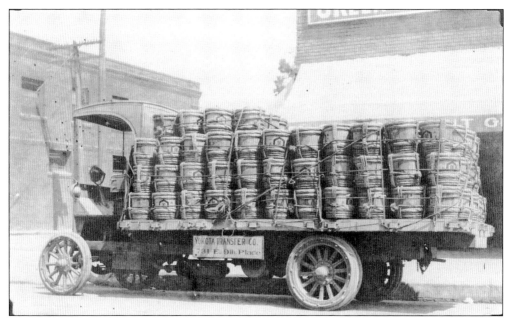

Yokota Transfer Company was located at 731 East Ninth Place near Crocker Street in close proximity to many wholesale produce markets near the southern border of Little Tokyo. The image above shows 181 barrels of Kikkoman brand *shoyu* (soy sauce) loaded onto one of Waroku Yokota's trucks in 1917. Below, pallets are loaded onto Yokota Transfer trucks around 1920. (Both courtesy of Kimiko Yokota.)

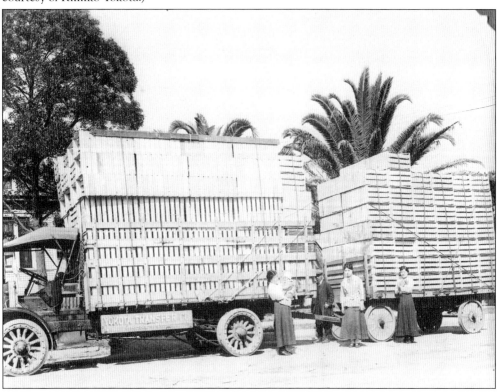

Walter Abe and partners started K and C Produce at the Wholesale Terminal Building shortly before World War II. Abe also owned the A.B.C. Crate Company, as wooden crates were necessary to transport produce from farm to wholesaler to retailer. The A.B.C. Crate Company was originally located at 773 Gladys Avenue and later relocated to South Santa Fe Avenue in the early 1960s. Also shown is an invoice statement from 1949. (Both courtesy of Janet Tsukamoto.)

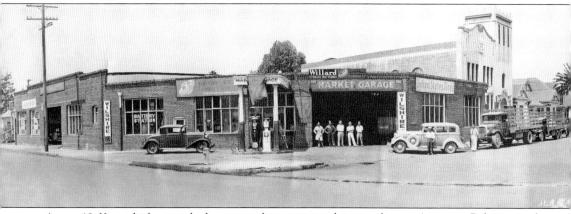

At age 18, Kazuichi Iwai worked on a merchant marine ship traveling to Antwerp, Belgium, and eventually made it to Los Angeles where he met and married his wife, Yasuko. They started Market Garage and Gas Station at 750 East Ninth Place and Crocker Street (shown here around 1935) that primarily serviced Japanese farmers from Imperial Valley who trucked their produce to the wholesale markets just south of Little Tokyo. Yasuko operated a small café on the property. After

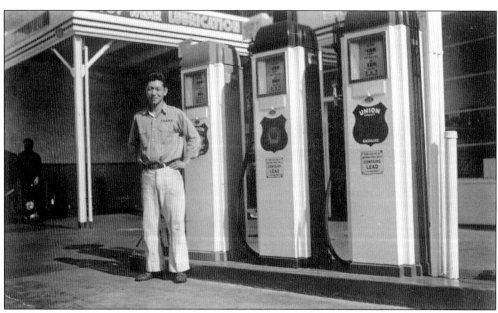

Jack Kuramoto stands at Jack's Auto Service in 1938, which was located on the northeast corner of East Second and San Pedro Streets from 1936 until he retired in 1983. He was such an expert mechanic that Hollywood celebrities Sammy Davis Jr., Sophia Loren, and film director John Ford brought their cars to be serviced. Kuramoto was also one of the early nisei hot-rodders. (Courtesy of Ford Kuramoto.)

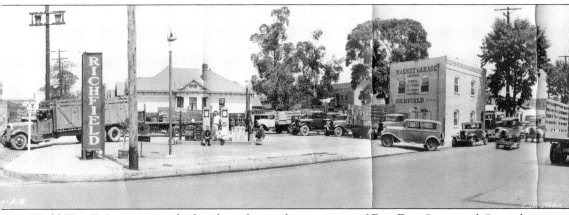

World War II, Iwai managed a hotel on the southwest corner of East First Street and Central Avenue and a produce stand near Fairfax and Melrose Avenues. He was one of the early pioneers of coin-operated laundromats; Iwai and his sons developed a chain of laundromats and dry cleaners throughout Los Angeles. (Courtesy of the Kazuichi Iwai family.)

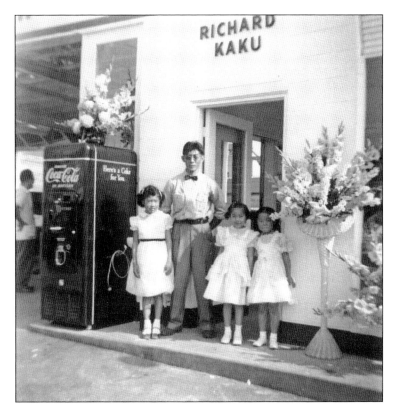

From left to right, Pat Kaku (daughter), Richard Kaku (proprietor), and Susann and Shirley Higashi (family friends) celebrate the opening day of his Mobil Gas Station in May 1954. The new business stood at Alameda and Commercial Streets. With the Civic Center, the flower and produce markets, the commercial warehouse district, and Union Station nearby, there were several service stations around the Little Tokyo neighborhood. (Courtesy of Richard Kaku.)

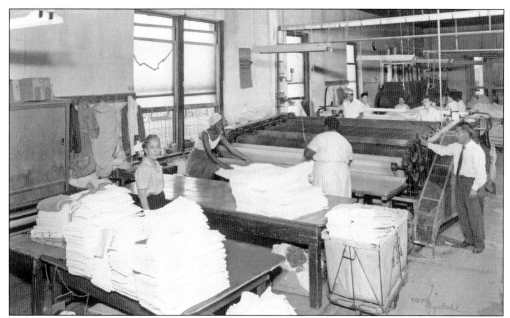

Located at 1520 Griffith Avenue, Sunrise Laundry was opened in the early 1920s by Zenkichi Murakami and his wife, Miyaji. The business serviced many Japanese hotels and took in laundry from families. In 1945, the Murakamis restarted the business. Most post-war employees were Japanese, but there were also a few African Americans and Mexican Americans, as seen in this 1969 photograph. (Photograph by Toyo Miyatake Studio, courtesy of Yoshiaki Murakami.)

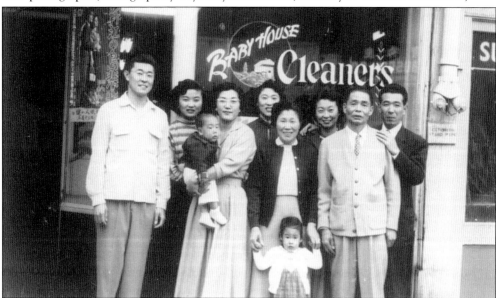

This 1952 photograph shows Baby House Cleaners, located at 341½ East First Street. Jenyemon and Mumeno Azeka were among the first families to open a business in Bronzeville/Little Tokyo after being released from the Manzanar War Relocation Center in 1945. Jenyemon purchased Baby House Cleaners from a Mr. Miller for about $200 and retained the whimsical name. There was an African American–owned barbershop and a shoe-shine parlor next door. (Courtesy of Sande Hashimoto.)

Barbershops and beauty salons abounded in Little Tokyo, necessitating the formation of the Japanese Barber Association, established in 1911 and located on East First Street. Isamu "Sam" Kihara is shown servicing a customer at his barbershop at 336 East First Street, which opened in late 1944. Kihara and his son Bob later moved the shop around the corner to the San Pedro Firm Building in the 1980s. (Courtesy of Robert Kihara.)

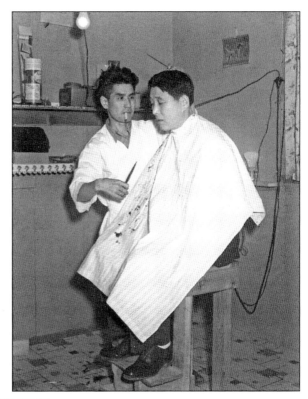

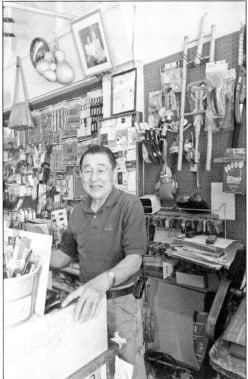

Anzen Hardware owner Norihiko Takatani stands amid unique tools and cutlery imported from Japan in this 2010 photograph taken at his 309 East First Street business. Split-toed *tabi* footwear, seeds, and sushi rice molds are also sold. Tsutomu Maehara started the original Anzen Hotel Supply Store in 1946, which carried janitorial and hotel supplies for the over 400 hotels in Los Angeles. (Photograph by and courtesy of Alvin Tenpo.)

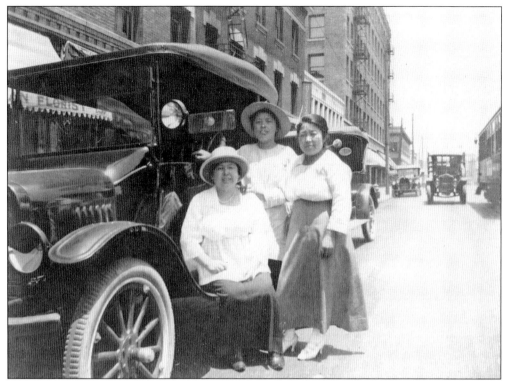

Sanba (midwives) delivered many nisei babies in Little Tokyo from the late 19th century until about 1950. Japanese midwives were formally educated and used what was considered modern techniques for prenatal, delivery, and postnatal care for issei women. Shown in this c. 1920 photograph looking north along South San Pedro Street are Tsuneko Okazaki (left) and Toku Urata (right) in front of the Hotel Pacific. (Courtesy of Jane K. Urata.)

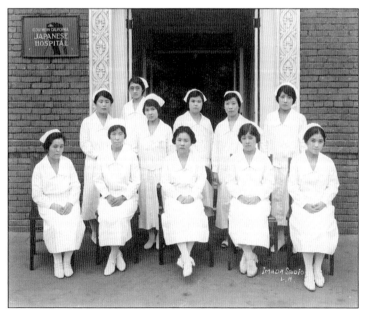

In response to the 1918 flu pandemic, a clinic on Turner Street was expanded and named Southern California Japanese Hospital, shown here in 1927. The hospital closed in 1935. By then, the Japanese Hospital of Los Angeles had opened (in 1929) in nearby Boyle Heights after attorney J. Marion Wright won the 1928 U.S. Supreme Court case, *Jordan v. Tashiro*, on behalf of five issei doctors. (Courtesy of JANM/Kuroiwa Collection.)

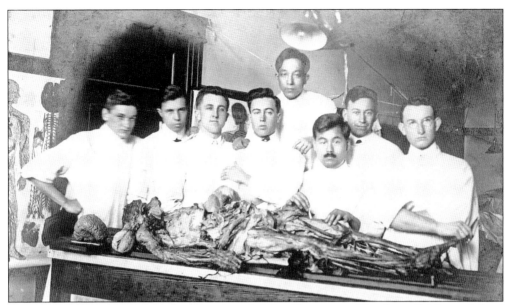

Nagisa Mizushima, holding a scalpel, stands with fellow University of Southern California School of Dentistry students in 1916, his graduation year. By 1917, he had opened a dental practice on the west side of North San Pedro Street across from the Union Church. He was one of the earliest Japanese to graduate from a dental school in Los Angeles. (Courtesy of the Mizushima family.)

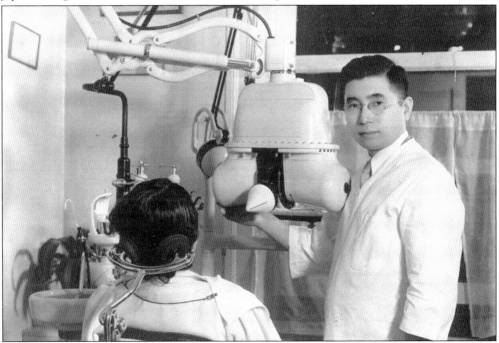

Dr. Yoshitaro Yoshimura is shown at his first dental office on Terminal Island before World War II. He was sent to the Poston War Relocation Center, where he was a camp dentist. After his family's release, they moved to Los Angeles where he established a practice in Little Tokyo that lasted over 40 years. His son Iwao took over the practice after Yoshitaro's retirement. (Courtesy of the Yoshimura and Shintani families.)

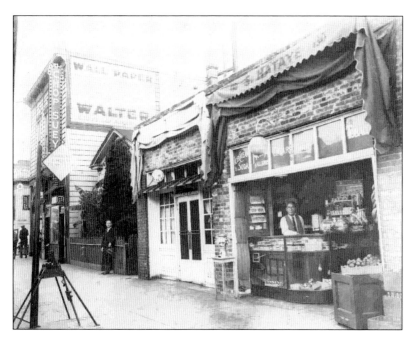

Shoichi Hataye, proprietor of Hataye Soda Fountain, is shown here in this c. 1930 photograph at his shop, located at 130 North San Pedro Street. He sold ice cream, soda, candy, tobacco, and cigars among other sundry items. (Courtesy of Masaji Hatae.)

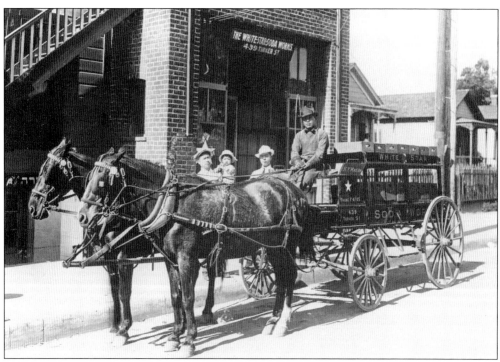

H. Y. Maeda sits on a delivery wagon in front of his company, White Star Soda Works, at 439 Turner Street around 1916. Many issei and nisei recall having soda pop from White Star Soda at *kenjinkai* (prefectural association) summer picnics. Note the Yiddish letters on the left—an indication of the Jewish community in the East First Street area for over a decade. (Courtesy of Toyo Miyatake Studio.)

Umekichi Nagamoto founded the Nagamoto *kamaboko* (fish cake) company at 313 Jackson Street in the early 1920s. His son Shozo succeeded him in 1924 when Umekichi returned to Japan. They restarted the business in 1949 at the same location in Little Tokyo following World War II until his retirement in 1958. Shozo's daughter Reiko Ohara (left) stands in front of the Nagamoto Company in May 1951. (Courtesy of Rei Kasama.)

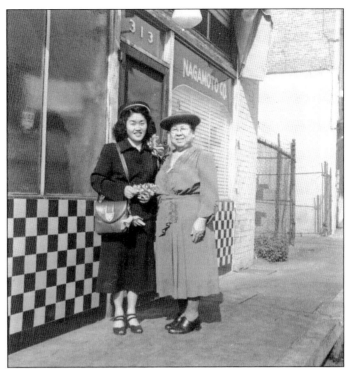

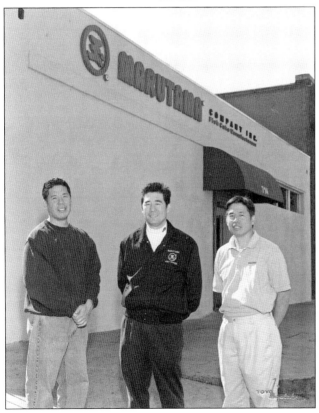

From left to right, Paige, Wade, and Jay Kato stand in front of their kamaboko business at 714 Towne Avenue. Tamaichi and Shizu Yoshiwa founded Marutama in Fresno in 1932. After Tamaichi's death, stepsons Kazuo and Ray Kato managed the business with their mother. After World War II, they moved to the site where the Aratani/Japan America Theatre now stands. They sold the property in 1953 and later moved to their present location. (Courtesy of the Kato family.)

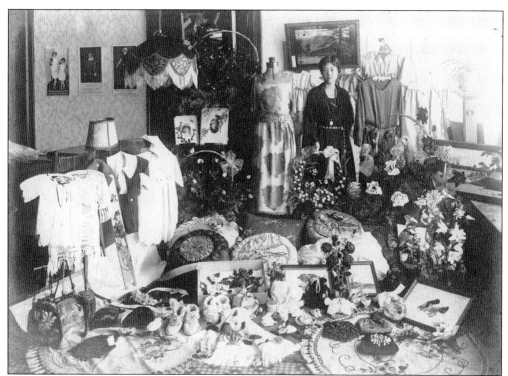

Shige Yokota is shown above with her exquisite handiwork around 1925. She learned these sewing skills from staff at the Broadway department store and in turn taught issei women in Little Tokyo. Yokota was the principal at one of the largest sewing schools in Little Tokyo during the 1920s, the Rafu Yossai Gakuen (Los Angeles Sewing College). The school was initially on Ninth Street and later moved to East Second Street between Central Avenue and San Pedro Street. Other sewing schools in early Little Tokyo included the French American Sewing School, the Parisian School of Fashion Arts, and Pacific Sewing School for nisei girls and women. The photograph below shows graduation day at Rafu Yossai Gakuen on September 14, 1924. Yokota is seated in the middle of the first row and is wearing a white dress. (Both courtesy of Kimiko Yokota.)

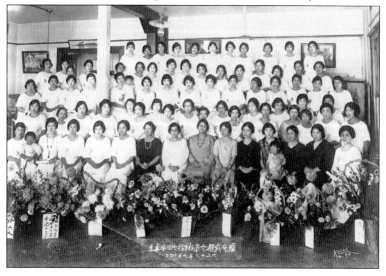

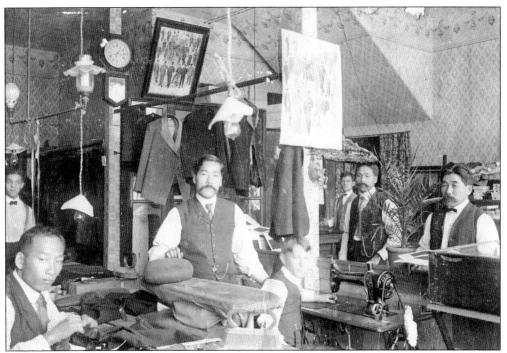

Specializing in men's suits, master tailor Kesajiro Urata and his wife, Toku, opened Matsuura Company Tailors at 133 South San Pedro Street with partner U. Matsuda. The successful business had branches in Oxnard, San Diego, Poway, Bakersfield, and agents in the Sacramento region. Urata was instrumental in the formation of many civic, cultural, educational, and religious institutions in Little Tokyo. This photograph was taken around 1910. (Courtesy of Jane K. Urata.)

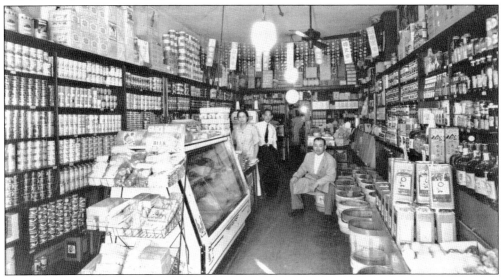

Mr. Nishimi (seated) is seen here inside his store, T. Nishimi Groceries, at 128 North San Pedro Street. This 1936 photograph shows Japanese and American goods with tins of Kikkoman brand shoyu and sake bottles on the right and empty shoyu barrels on the floor. Also in the photograph are Mrs. Nishimi and Kotaro Yamaguchi, their employee. (Photograph by Yamakishi, courtesy of Tadashi and Atsuko Kowta.)

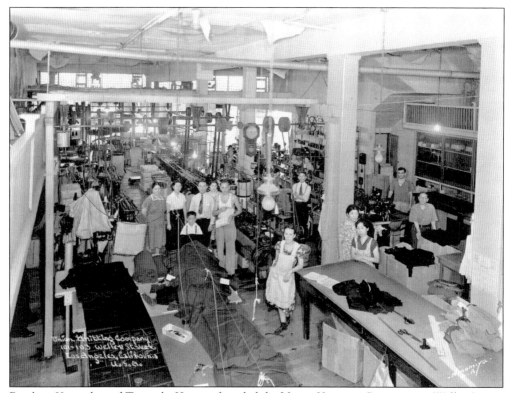

Brothers Kinzuchi and Toyosuke Kimoto founded the Union Knitting Company on Weller Street. Their orders included sweaters and jackets for parochial schools and contract work for large Jewish apparel manufacturers. After World War II, Kinzuchi reopened the business while Toyosuke went to work as a writer at the *Rafu Shimpo*. Kinzuchi's wife, Kayo, continued the business until 1963. This prewar photograph shows their factory. (Photograph by Ninomiya, courtesy of Masaye Masuyama Shigemura.)

Akiko (Otani) Uyeda opened Naomi's Dress Shop at 116 North San Pedro Street. This photograph shows Akiko and her husband, John, around 1970. They met in Osaka, where he was stationed as a translator during the Occupation of Japan following World War II. The shop later moved to the Japanese Village Plaza in the late 1970s. (Courtesy of Mark and Betty Uyeda.)

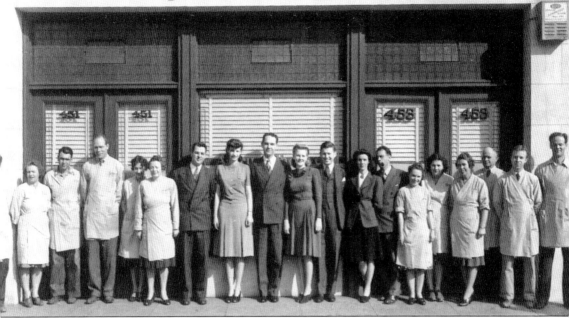

In 1935, Stanton Avery rented a 100-square-foot loft above the San Lorenzo Nursery on South Wall Street, where he packed flowers and assembled a crude machine to die-cut self-adhesive labels. Avery was a Pomona College classmate of Joe Shinoda, whose family owned the nursery. Avery's label business flourished, and in 1940, he moved his Avery Adhesives company to 453 East Third Street in Little Tokyo, where this photograph was taken. Avery, the tall central figure in the photograph, is shown along with his employees. The company is now known as Avery Dennison, a multinational, multibillion-dollar conglomerate. The site today is home for hundreds of older residents who live at the Little Tokyo Towers senior housing project. (Courtesy of the Avery family.)

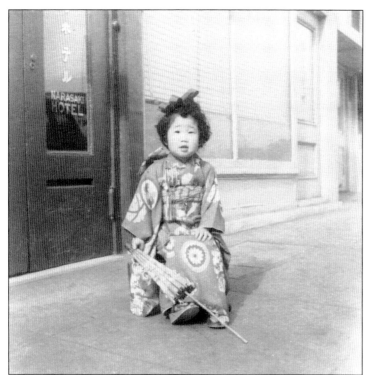

Linda Yamamoto, granddaughter of Masajiro and Miyoko Narasaki, sits with a *higasa* sun parasol in front of the Narasaki Hotel on Weller Street around 1950. It was not a conventional hotel but more like an apartment building where families rented living quarters. In the early 1970s, properties along Weller Street were razed, and the New Otani Hotel and Weller Court were constructed. (Courtesy of Shigeji and Fumie Ito.)

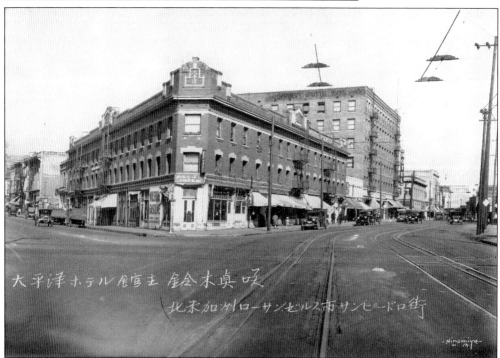

The Hotel Pacific stood at 121–139 South San Pedro Street on the southeast corner of Weller and San Pedro Streets. In this undated photograph, the large hotel is shown alongside the Pacific Electric Red Cars tracks. (Photograph by Ninomiya, courtesy of Mike Murase.)

From the southwest corner of South San Pedro Street looking west along East First Street stands the famous Miyako Hotel around 1950. Next door to the Miyako Hotel was the New Ginza Theater, Enbun Company, Joseph's, S. K. Uyeda Company, San Kwo Low Chop Suey, and Anzen Hotel Supply Company. Across Weller Street is the Union Knitting Company. (Courtesy of Mike Murase.)

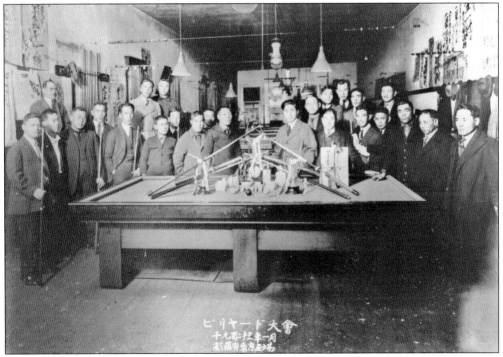

As early as 1907, about 20 percent of billiard parlor businesses in Los Angeles were Japanese owned. Issei men outnumbered Japanese women 10 to 1, so billiards was a very popular activity. In 1940, there were about 20 such establishments in Little Tokyo. This is a billiard competition in January 1923 at the Tokyo Pool Hall. (Courtesy of Toyo Miyatake Studio.)

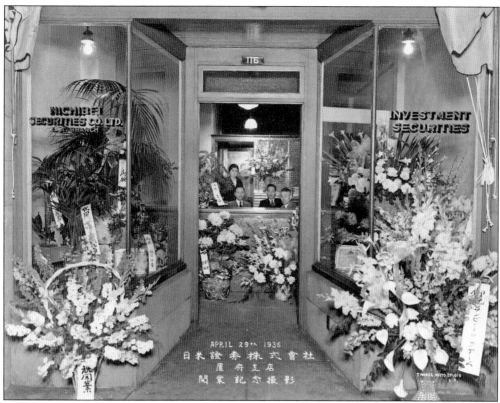

In the early 20th century, Japanese-owned banks and financial companies were prevalent in the neighborhood: Yokohama Specie Bank Ltd., Sumitomo Bank, California Bank, Japan America Bank, and the Golden Gate Bank. The latter two failed in the wake of the Panic of 1908. This photograph was taken to commemorate the opening day of Nichibei Securities Company Ltd. at 116 South San Pedro Street in April 1936. (Courtesy of the Wakita family.)

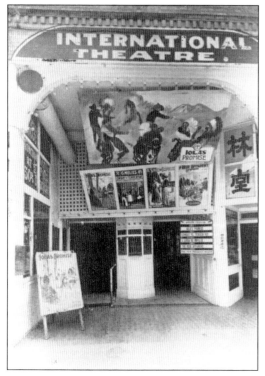

The International Theatre, located at 228 East First Street, was established in 1906 as the first cinema house in Little Tokyo. The proprietors were Bungoro "George" Tani and Tadayoshi Isoyama. In 1925, the site was converted to San Kwo Low Chop Suey, attracting Charlie Chaplin and other Hollywood stars. (Courtesy of Toyo Miyatake Studio.)

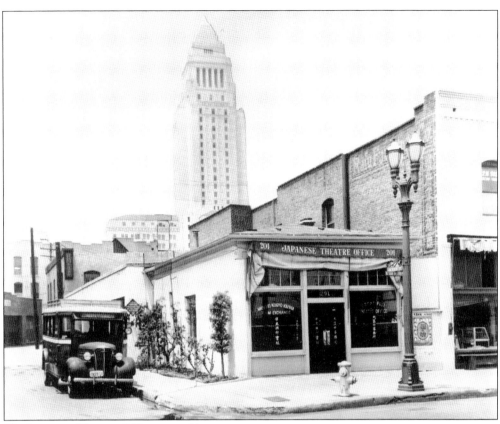

The Japanese Theater Office was a film brokerage firm at 201 North San Pedro and Jackson Streets. The sign on the left window reads, "Nichibei Kogyo Kaisha, Film Exchange," while the sign on the right window notes, "Great Fuji Theater Office." The Sumo Kyokai (Sumo Association) was also a tenant of the building. The photograph is dated August 2, 1940. (Courtesy of Toyo Miyatake Studio.)

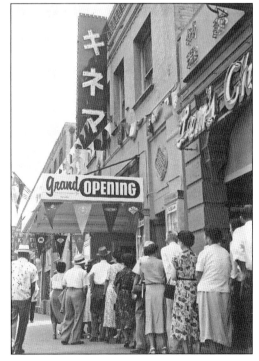

August 13, 1955, was the opening day for the Kinema Theater, operated by Toshinori Kumamoto. Japanese films were screened at the 354-seat movie theater at 322 East First Street. Kinema was on the former site of the beloved Fujikan Theater of the pre–World War II period. Next door to the theater was Lem's Chop Suey, a popular China *meshiya*, or Chinese restaurant. (Courtesy of JANM, Miyatake Studio/*Rafu Shimpo*.)

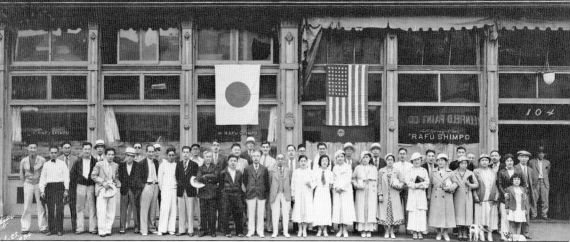

The *Rafu Shimpo* began in April 1903 at 128 North Main Street as a weekly Japanese-language news bulletin by three issei: Eitaro Iijima, Seijiro Shibuya, and Masaharu Yamaguchi. In the days of anti-Japanese sentiment in California, it became a prominent community voice and continues to be a major influence within the Japanese American community today. In 1926, under its sixth publisher, H. T. Komai, the *Rafu Shimpo* began publishing a one-page English section for the American-born nisei. The publication is in its third generation of family ownership with publisher Michael Komai. It remains the largest and oldest Japanese-English newspaper outside of Japan. (Photograph by S. Izuo Toyo Studio, courtesy of the *Rafu Shimpo*.)

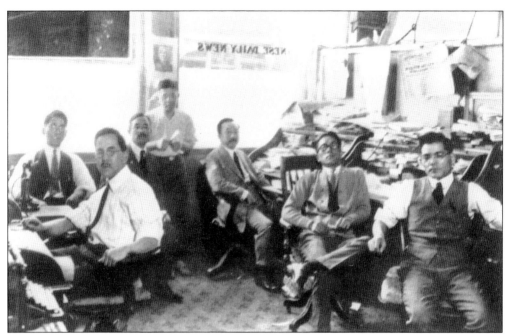

This c. 1926 photograph shows the editorial staff of the *Rafu Shimpo* and includes Hiroshi Suzuki (second from left in the white shirt), editor-in-chief of the Japanese section. (Courtesy of Toyo Miyatake Studio.)

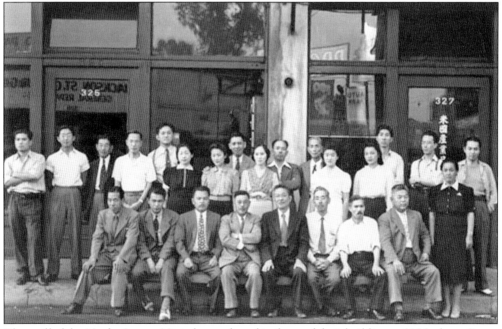

The staff of the *Nanka Sangyo Nippo* has gathered in front of their building at 325 Jackson Street at Yamato Hall around 1938. The Japanese-language newspaper had morning and afternoon editions that specialized in agricultural and industrial news, listing wholesale produce prices for produce market workers and farmers. In August 1938, it was renamed *Beikoku Sangyo Nippo* under publisher Koh Murai (first row, center, in dark suit). (Courtesy of Sets [Izumi] Asano.)

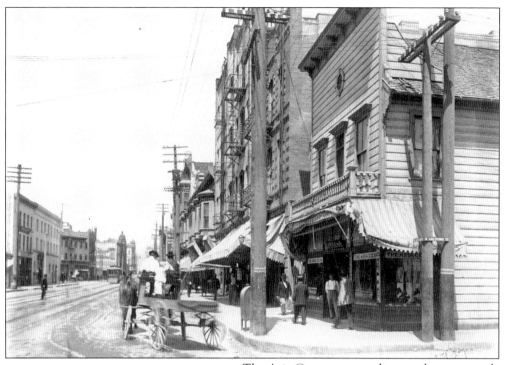

The Asia Company, a trading goods store, stood on the northwest corner of First and San Pedro Streets in 1907. Established by Bungoro Morey, it was the largest Japanese-owned business in Los Angeles by the 1920s. After losing the business during World War II, Morey later opened a rice wholesaler shop. In 2010, Joshua Morey reestablished the family presence in Little Tokyo by opening a branch of their insurance company. (Courtesy of the Morey family.)

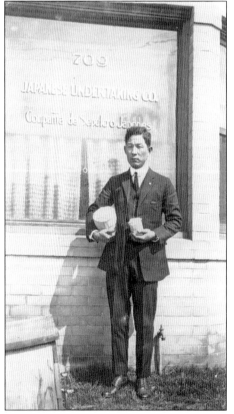

Soji Fukui left the sugarcane fields of Hawaii, migrated to Los Angeles, and found work as a funeral director for the Japanese community in Little Tokyo. In 1918, he assumed ownership of the Japanese Undertaking Company (later renamed Fukui Mortuary) at 709 East Temple Street. Fukui Mortuary is now in its fifth generation of ownership and management and remains at the same location. An unidentified employee stands in front of the business. (Courtesy of the Fukui family.)

Fugetsu-do was founded in 1903 by Seiichi Kito and Mr. Furukawa on Wilmington Street and is the oldest Japanese confectionery in Little Tokyo. Kito briefly returned to Japan to train in the art of creating *wagashi* (traditional sweets). Upon his return, he opened a new shop at 245 East First Street. He is said to have invented the fortune cookie, but tucked inside the cookie was a haiku poem instead of a fortune. After relocating to the neighborhood after World War II, Seiichi reopened where Fugetsu-do stands today at 315 East First Street. His son Roy succeeded in 1951, and now grandson Brian Kito runs the shop. Branding irons and molds that are still in use are shown in the photograph below. (Photographs by and courtesy of Alvin Tenpo.)

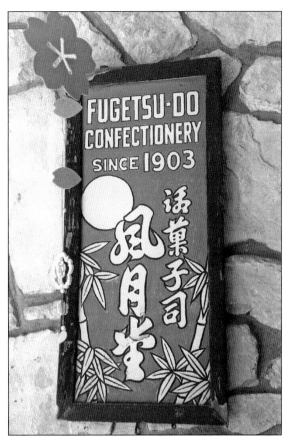

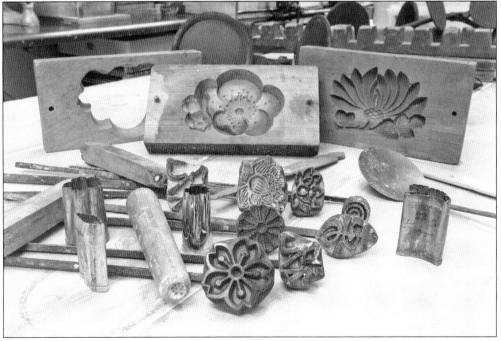

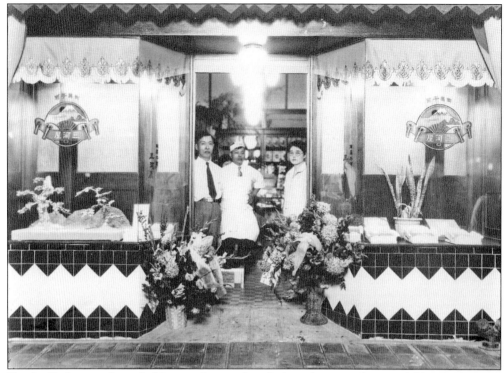

Koroku Hashimoto, his wife, Haru, and an unidentified employee are shown at Mikawaya at 244½ East First Street around 1925. Ryuzaburo Hashimoto purchased Mikawaya in 1910, and 15 years later, nephew Koroku acquired the business. Daughter Frances Hashimoto and her husband, Joel Friedman, run Mikawaya today. They are the creators of the popular *mochi* ice cream that was introduced in 1994. (Courtesy of Frances Hashimoto.)

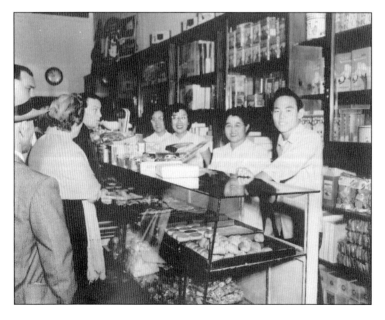

Mikawaya employees are serving customers eager to purchase handmade Japanese wagashi and *manju* (sweet red bean paste encased in pounded sweet rice) around 1950. It was customary to present a box of manju for special occasions. Confections imported from Japan were also popular gift items. Haru Hashimoto is second from the right in this photograph. (Courtesy of Frances Hashimoto.)

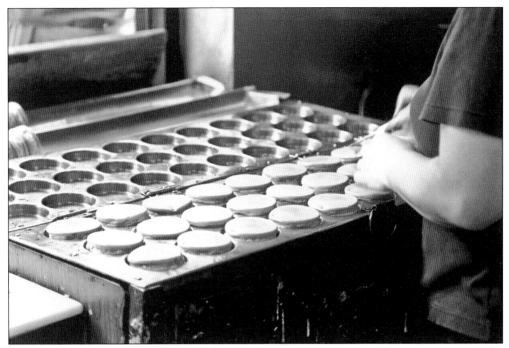

This 2010 photograph shows *imagawayaki* being prepared on a special grill at Mitsuru Café in the Japanese Village Plaza. This traditional snack is made of a pancake-like dough filled with sweet red bean paste. The imagawayaki is prepared behind the restaurant's front window, making it a popular attraction for people walking through the plaza. (Photograph by and courtesy of Jay Ian.)

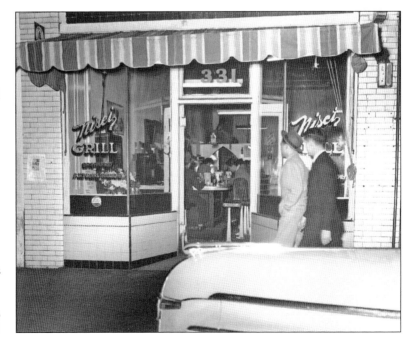

Amid the hustle and bustle of a reinvigorated postwar Little Tokyo, Nisei Grill was a favorite hangout where patrons could get a quick breakfast, short orders, and sandwiches. Opened in 1946 at 331 East First Street in the Mikado Hotel, this early-1950s photograph shows the modern look of the diner. (Courtesy of Toyo Miyatake Studio.)

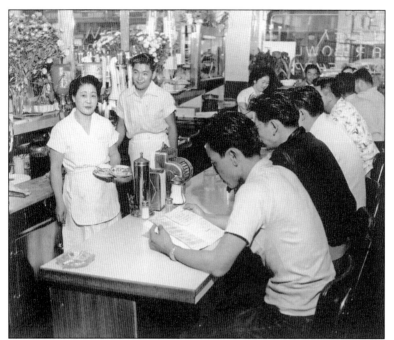

Nisei Sugar Bowl Café was a popular diner where hamburgers, steaks, and Japanese food were served. Located in the Taul Building on South San Pedro Street, it was owned by the Takahashi family and managed by son Giro and his mother, Tome, who are seen in this photograph taken in the 1950s. Frank's Pool Hall was in the basement. (Courtesy of Toyo Miyatake Studio.)

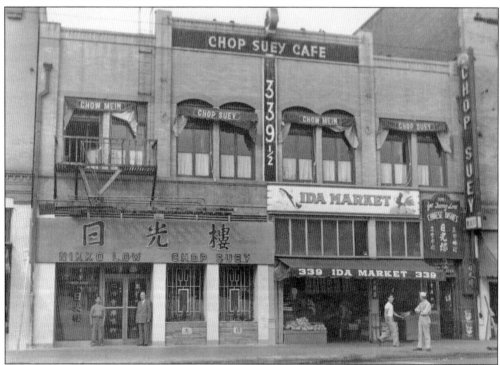

Walking along First Street meant enjoying enticing aromas from the various Chinese restaurants, including Nikko Low Chop Suey, shown here around 1940. Many of these restaurants had banquet rooms, so they were popular wedding reception and after-funeral venues. After making their deliveries to the produce markets, Japanese farmers often enjoyed an inexpensive and hearty China meshi meal before heading back to their farms. (Courtesy of Henry Fong.)

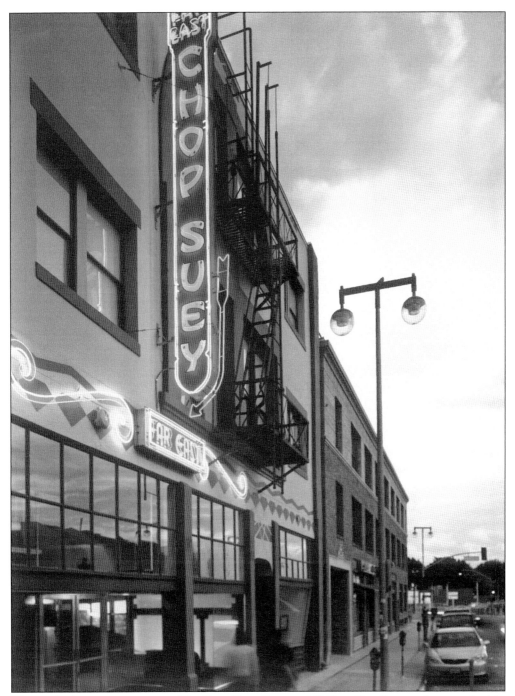

This is the latest incarnation of Far East Chop Suey at 347 East First Street, photographed in 2004. Issei and nisei especially came to eat their *hom yu*, a dish made of steamed pork and pork fat. The 1896 Beaux-Arts building closed after suffering significant damage from the 1994 Northridge earthquake. The seismic restoration was costly, but the restaurant reopened as Chop Suey Café in 2006. The original restaurant was opened in 1937 by five cousins and was a popular gathering place. (Courtesy of Little Tokyo Service Center Community Development Corporation.)

Nisei Kiyoshi "Banjo" Tanahashi (left) switched clothes with his Japanese cousin for this photograph taken in Gifu, Japan, around 1920. Banjo was delivered at home with the assistance of a midwife. The family's residence was connected to their business, Asahi Dye Works, on the north side of First Street. Many nisei had interesting nicknames. Banjo was derived from entertainer Eddie Cantor's nickname, "Banjo Eyes," because of Tanahashi's large round eyes. Like many other nisei who grew up in the neighborhood, he helped with the family business from an early age and used Little Tokyo as a playground. (Courtesy of the Tanahashi family.)

Two

TRADITIONS

Japanese immigrants came to the United States armed with a sense of adventure and hope for the future. They also brought traditions from Japan that were transformed as they forged new lives in America.

Kenjinkai, associations based on the prefecture of origin, were formed as mutual aid societies to help immigrants from the same region adjust to their new homeland. Traditional banks did not readily lend to Japanese immigrants, so they formed revolving credit associations, known as *tanomoshi*. By participating, shopkeepers, business people, and families could have access to capital when in need. Buddhist temples instituted Sunday services, something anathema in Japan but an important part of American religious practices. Christian churches offered an array of social services, including etiquette classes, to help immigrants adjust to American culture.

Oshogatsu, or the Japanese New Year, is the most important holiday celebrated in Japan each year. Japanese Americans observe the day by combining traditional foods with American fare, as well as continuing the tradition of *mochitsuki*, or the making of pounded rice cakes. A family might also celebrate Hinamatsuri, or Girls' Day, by displaying the traditional ornamental dolls representing the emperor, empress, and their courts, but combine it with an American tea party.

The biggest annual event in Little Tokyo is Nisei Week. Established in 1934, it was a way for the nisei to assert their American identity while honoring their unique bicultural heritage. Nisei Week encompasses more than a week of cultural displays, martial arts demonstrations, a fashion show, parade, Japanese dancing, and coronation of a queen and her attendants, among other events. From its onset, Nisei Week attracted visitors and dignitaries from beyond Little Tokyo's borders. Los Angeles mayor Fletcher Bowron and Charlie Chaplin were among those to participate in the pre–World War II period. Today Nisei Week continues as a Little Tokyo tradition.

Issei and nisei from the Southern California Kumamoto Kenjinkai gather on Jackson Street near

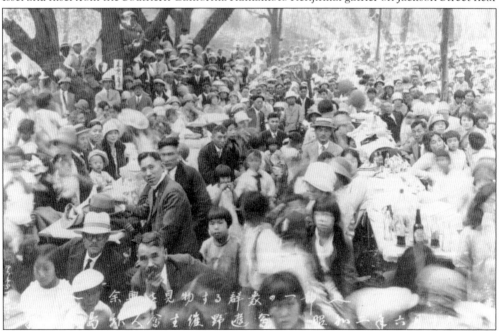

The Southern California Hiroshima Kenjinkai have gathered here in the summer of 1927 for their annual picnic at East Lake Park (today's Lincoln Park). Each kenjinkai had their own events, with members bringing traditional *bento* (Japanese boxed lunches) along with watermelon, sodas, and other treats. Everyone joined the performances, games, and races in friendly competition. (Courtesy of Mike Murase.)

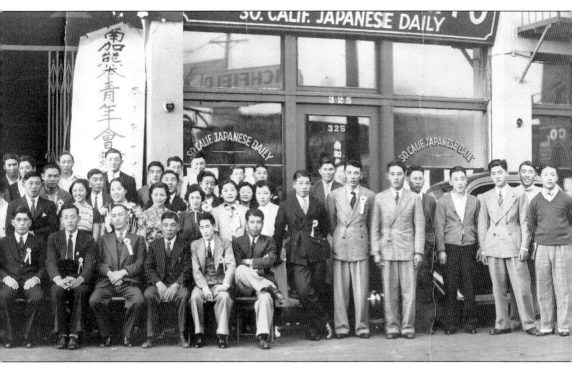

Yamato Hall and the *Sangyo Nippo* newspaper in April 1938. (Courtesy of the Nagano family.)

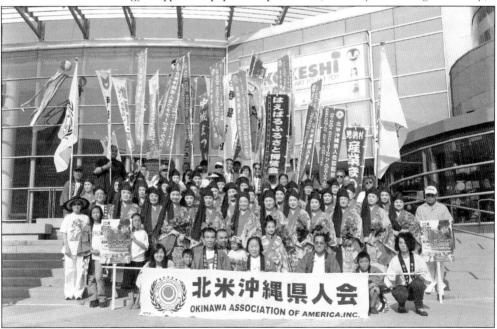

In 1909, Okinawan immigrants from San Francisco and Mexico came together in Los Angeles and formed the Nanka Okinawa Kenjinkai. Presently known as the Okinawa Association of America, Inc., they maintain the goals of mutual aid and fostering Okinawan identity and actively participate in the larger Japanese American community, as seen here at the 2009 Nisei Week Festival. (Courtesy of Ben T. Higa.)

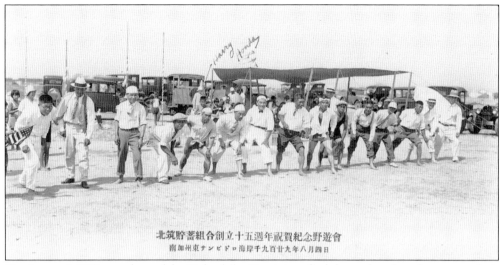

On August 4, 1929, members of the Hokuchiku Kumiai readied themselves for a footrace at their 15th Anniversary Beach Party at East San Pedro Beach. Kumiai was a tanomoshi club founded in Los Angeles in 1914. Tanomoshi is a form of financial assistance where members would contribute towards a pot before taking turns receiving cash in order to set up a farm or business or purchase a home. (Courtesy of Harry Honda.)

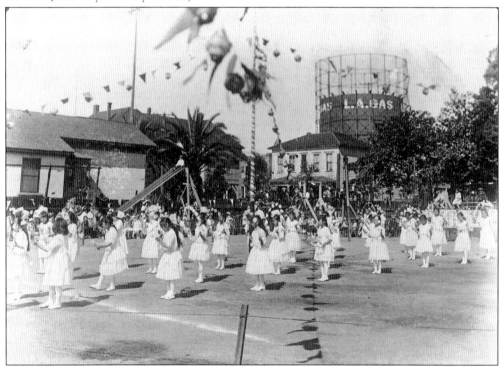

Kohei Shimano and Kesajiro Urata founded Rafu Daiichi Gakuen, Los Angeles's first Japanese language school, in 1911. The school was located at 318 North Hewitt Street. This building previously served as an industrial school for minority boys and was known as the Stimson Lafayette Building, where Americanization classes were held. This photograph shows Daiichi Gakuen students participating in a May Day festival around 1920. (Courtesy of Kimiko Yokota.)

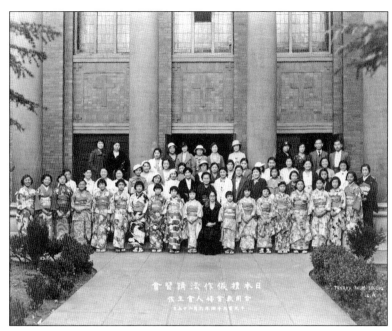

Members of the Fujinkai (women's association) of the Japanese Union Church of Los Angeles gather in front of their North San Pedro Street church for a Japanese etiquette seminar held in June 1934. The classes were held to foster Japanese traditions. (Photograph by Tanaka Photo Studio, courtesy of Union Church.)

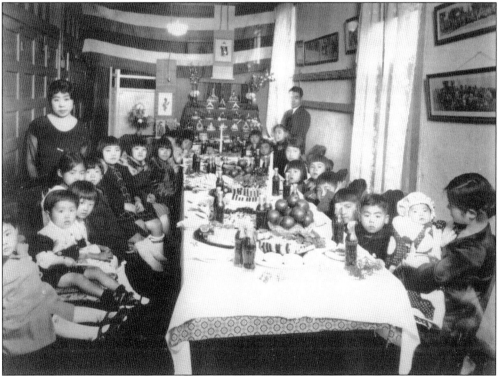

March 3 is Hinamatsuri (literally "doll festival"), or Japanese Girls's Day, celebrated to wish girls happiness and good health. Families celebrate with special foods such as *chirashi-zushi* (mixed sushi rice), *sakura mochi* (cherry leaf rice cake), *hina-arare* (rice crackers), and by displaying elaborate doll displays. The photograph shows a Girls's Day celebration at Koyasan Daishi Mission on Central Avenue around 1925. (Courtesy of Toyo Miyatake Studio.)

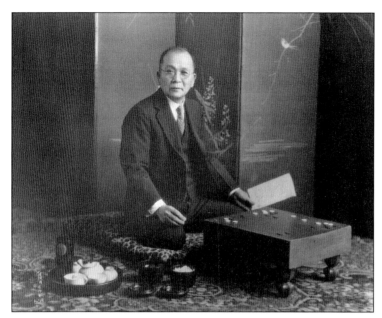

Honryu Konishi was a master instructor and founder of the Go Center of Los Angeles on Weller Street. Go is an ancient board game from China that was brought to the United States via Japanese immigrants. It was very popular among many issei. Go is a complex game requiring equal strength in both defensive and offensive strategy. (Photograph by Terachi, courtesy of the Wakita Family.)

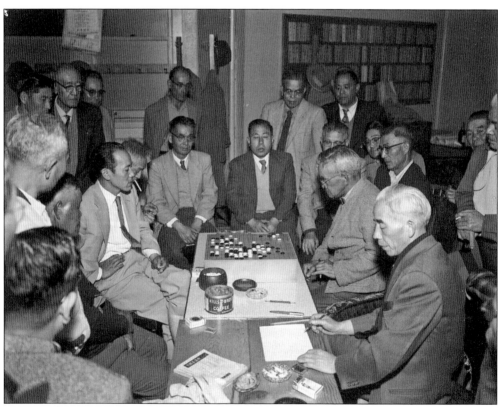

A group of men watch go players at the annual Gokai Sho (Go Center) Tournament in the Sun Building on Weller Street on March 6, 1956. The Sun Building had residences and housed many cultural organizations. It was torn down in the 1970s to build the New Otani Hotel. (Courtesy of JANM, Miyatake Studio/*Rafu Shimpo*.)

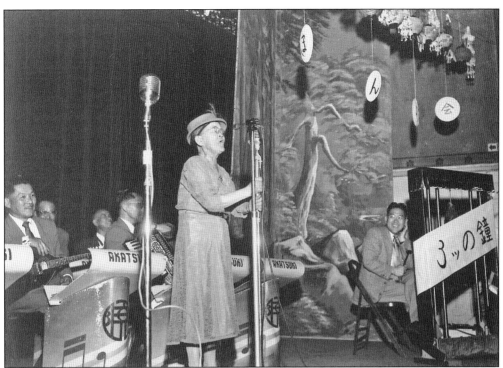

A contestant performs at the Nodo Jiman singing contest at the Los Angeles Hompa Hongwanji Buddhist Temple on May 20, 1956. The popular event invited amateurs to sing, accompanied by the Akatsuki Band, until three bells rang indicating they had cleared the round. However, if a gong was struck before the bells rang, it signaled elimination. A winner was selected at the end of the competition. (Courtesy of JANM, Miyatake Studio/*Rafu Shimpo*.)

Yamato Hall, a three-story building at 325 Jackson Street, was the center for many cultural, educational, and social activities in Little Tokyo from 1916 through 1940. It housed the Los Angeles Hompa Hongwanji Buddhist Temple (1917–1923) and the *Rafu Nichi Bei* (1922) and *Sangyo Nippo* (1937) newspapers. The top floor was the Yamato Club (later Tokyo Club), a well-known spot for gambling. (Courtesy of Los Angeles Hompa Hongwanji Buddhist Temple.)

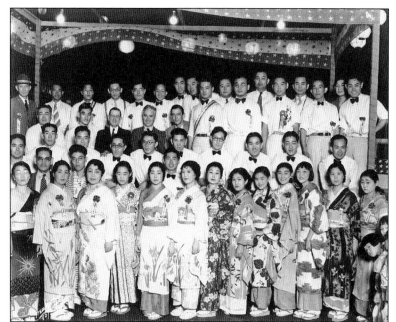

Nisei Week was organized as a way to reinvigorate Little Tokyo businesses that were languishing during the Depression. The festival began in 1934 with Charlie Chaplin as its first grand marshal. He is included in this photograph (second row from the top, fourth from left) with dance teachers and volunteers. (Courtesy of Evelyn Yoshimura.)

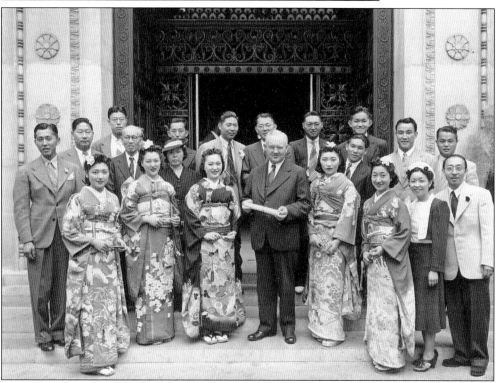

In 1940, Nisei Week Queen Shizue Kobayashi and her court met with Los Angeles mayor Fletcher Bowron at city hall. Just a year later, Bowron was credited with making statements supporting incarceration of the Japanese Americans during World War II. After the war, he stated his regrets and downplayed his influence in advocating the detention of Los Angeles's Japanese. (Photograph by Toyo Miyatake, courtesy of Harry Honda.)

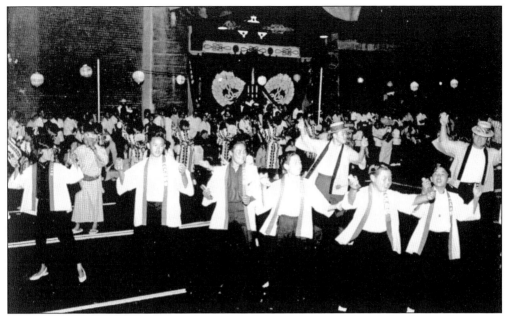

Obon is a festival that is meant to be joyful while celebrating life and the departed spirits of ancestors. *Bon odori*, or obon dancing, is customary at these festivals. Youth from the Venice branch of the Los Angeles Hompa Hongwanji Buddhist Temple participate in bon odori at the site of the original temple on Central Avenue and First Street around 1962. (Courtesy of the Los Angeles Hompa Hongwanji Buddhist Temple.)

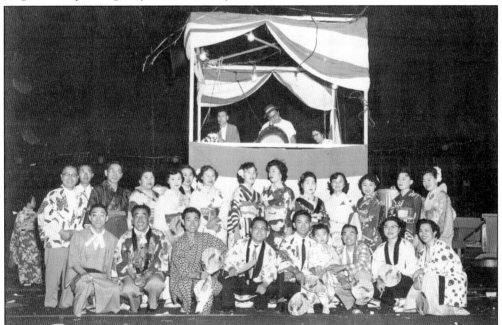

Members of the Los Angeles Hompa Hongwanji Buddhist Temple gather for a photograph with the *yagura* (tower) at their 1955 obon festival. The yagura is a high wooden scaffold made for the festival that serves as the bandstand for the musicians and singers of the bon music. (Courtesy of the Los Angeles Hompa Hongwanji Buddhist Temple.)

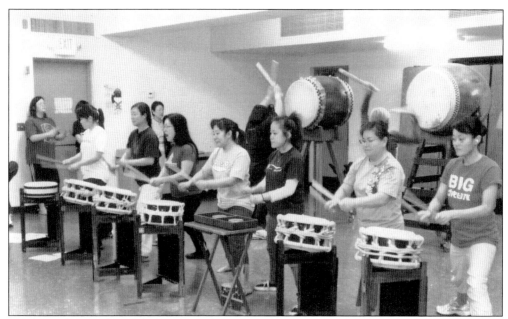

Bombu Taiko was founded in 2002 at the Los Angeles Higashi Hongwanji Buddhist Temple at Third Street and Central Avenue. Rinban Noriaki Ito chose this name, as it refers to the "Bombu" of Buddhist philosophy, which loosely translates as "ordinary people" or "the unenlightened masses." It embodies the Buddhist taiko philosophy that emphasizes letting go of one's ego and just having fun. (Photograph by and courtesy of Hal Keimi.)

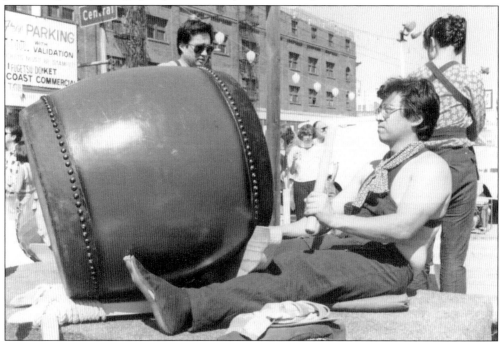

Rev. Tom Kurai, George Tashiro, and Fumiko Ito of Sozenji Taiko get ready to perform in the 1984 Nisei Week Parade. Reverend Kurai, of the Sozenji Buddhist Temple in Montebello, California, formed the group in 1978. (Courtesy of Rev. Tom Kurai.)

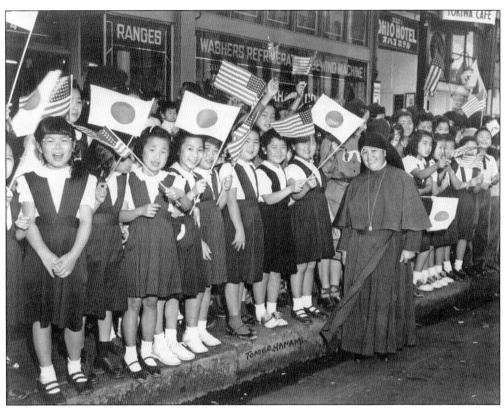

Sister Bernadette and Maryknoll School students line the street in front of the Ohio Hotel and the Tokiwa Café in Little Tokyo, welcoming Japan's Crown Prince Akihito and his wife, Princess Michiko, in 1953. (Photograph by Tomeo Francis Hanami; courtesy of Japanese Chamber of Commerce of Southern California, History Committee.)

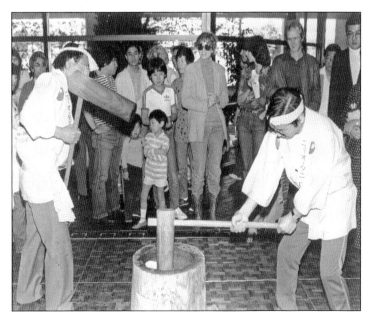

Mochi is a rice cake made of glutinous rice pounded and molded into a round shape. It is traditionally made in a ceremony called *mochitsuki* and is an important food eaten at New Year celebrations. In this late 1970s photograph, men from the New Otani Hotel rhythmically pound cooked rice using the traditional *kine* (wooden mallet) and *usu* (mortar). (Courtesy of Japanese Chamber of Commerce of Southern California, History Committee.)

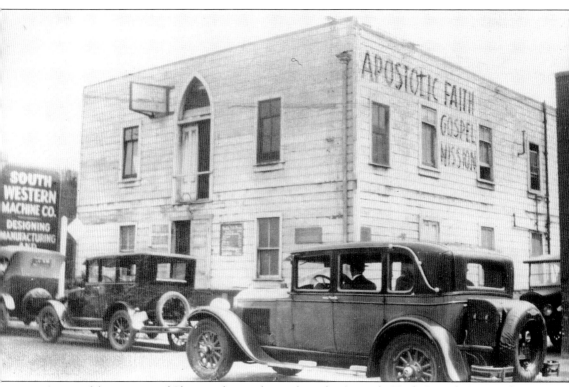

A powerful movement of Christian history began from the Apostolic Faith Gospel Mission, shown in this 1928 photograph taken at 312 Azusa Street. The site has a rich and diverse history. The building was originally the home of the First AME (African Methodist Episcopal) Church founded by Biddy Mason, a former slave who became a wealthy downtown landowner. It is now the Japanese American Cultural and Community Center Plaza. The founder of the mission, Pastor William J. Seymour, preached a message of salvation, holiness, and power that drew multiracial participants from all walks of life. From 1906 through 1912, this building housed the Azusa Street Revival that spawned the growth from a single church in 1906 to over 600 million adherents of the worldwide Pentecostal and charismatic denominations in 2006. In April 2006, about 3,000 people gathered at the site to mark the 100th anniversary of the movement. The centennial celebration worship service was held at Union Church of Los Angeles, which the Azusa Street Mission has been using for services since about 1999. (Courtesy of Flower Pentecostal Heritage Center.)

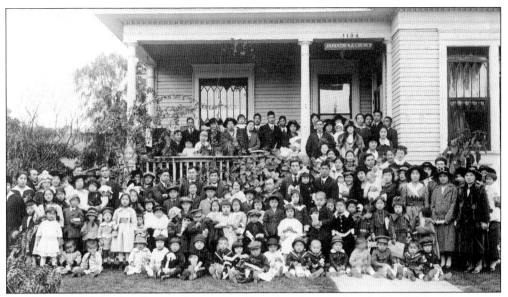

The Japanese Methodist Episcopal Mission of Los Angeles was founded in 1896, with services held at 252 Winston Street. In 1925, a new church was constructed at Normandie Avenue and 35th Street and was renamed Centenary Methodist Church. The congregation chose to return to Little Tokyo in 1988 and built a church on Third Street and Central Avenue. Sunday School children pose for this Christmas portrait in 1919. (Courtesy of Mike Murase.)

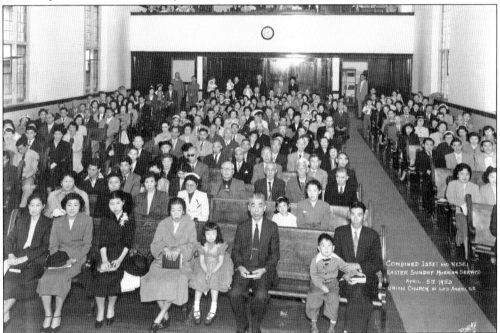

In 1918, three Protestant churches merged to become the Japanese Union Church of Los Angeles. A church was built at 120 North San Pedro Street in 1925. The congregation was renamed Union Church of Los Angeles in the 1950s. In 1975, a new church was built on the corner of Third and San Pedro Streets. Issei and nisei with their sansei children are shown here observing Easter morning service on April 5, 1953. (Courtesy of Union Church.)

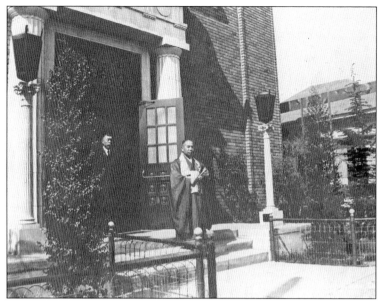

In 1922, Rev. Hosen Isobe established the Zenshuji Soto Mission. It was the first Soto Zen Buddhist temple in North America. Returning from a World War II concentration camp in May 1945, Bishop Daito Suzuki worked to restore Zenshuji. Today it is a thriving family-oriented temple that offers Zen practice for the lay practitioner. (Courtesy of Jane K. Urata.)

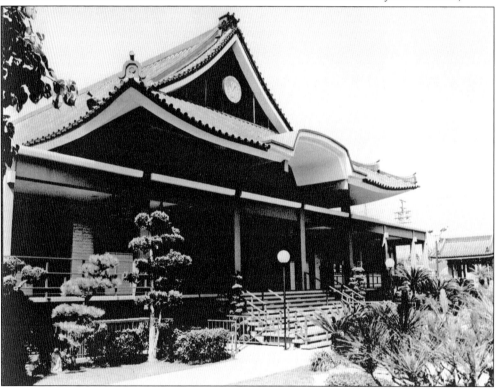

The Los Angeles Hompa Hongwanji Buddhist Temple has served Southern Californians since 1905. An architecturally distinctive new temple was built on the corner of First Street and Central Avenue in 1925. The building, now on the campus of the Japanese American National Museum, is listed in the National Register of Historic Places. The current temple at First and Vignes Streets, shown here, was completed in 1969. (Courtesy of Los Angeles Hompa Hongwanji Buddhist Temple.)

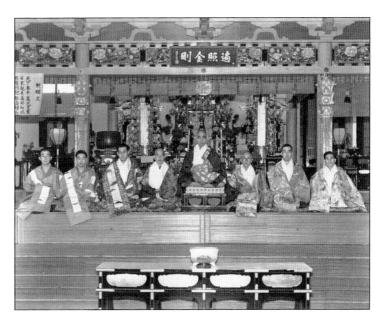

Los Angeles Koyasan priests with priests from the Koyasan headquarters in Japan participate in the dedication ceremonies for their new temple on First Street in 1940. Recognizing a need for spiritual guidance among Japanese laborers, Rev. Shutai Aoyama established the Koyasan Daishi Mission in 1912. (Photograph by Toyo Miyatake Studio, courtesy of the Takahashi family, from the Abbot Seytsu Takahashi Collection.)

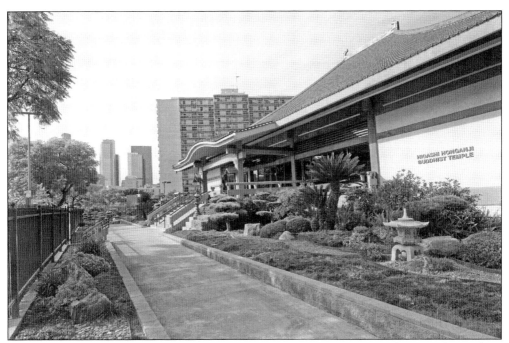

Higashi Hongwanji Buddhist Temple traces its roots to 1904 and the vision of Reverend Izumida. It was originally located on Fourth Street and named the Los Angeles Buddhist Mission. The present temple and garden are at Third Street and Central Avenue, as shown in this 2010 photograph. (Photograph by and courtesy of Alvin Tenpo.)

Kimiko Yokota's life reflects the tumultuous experiences of many *kibei*, or nisei, raised both in the United States and Japan. She grew up in Little Tokyo and the neighborhood near today's Exposition Park before moving to Japan in the 1930s. She raised a family in Hiroshima and survived the atomic bombing. She returned to the United States after voting in the first election open to Japanese women in 1946. (Courtesy of Kimiko Yokota.)

Three

COMMUNITY

Little Tokyo has transformed from an ethnic enclave borne of restrictive racial housing covenants to a neighborhood of diverse residents and businesses. What has remained constant is a sense of community. The earliest immigrants established houses of worship, but these served more than spiritual needs. Fujinkai (women's associations), Young Buddhist Associations, and Boy and Girl Scout troops sponsored by the churches and temples fostered group identification, service to community, and forms of social interaction. Informal groups formed clubs, organized dances, or extended service to others in need.

World War II interrupted life in Little Tokyo, but the same spirit of community drew Japanese Americans to return and reestablish the community after years of incarceration. Even as Japanese Americans began to move to other neighborhoods after a 1948 Supreme Court decision removed the housing covenants, they still flocked to Little Tokyo for social activities, shopping, and religious services.

Community activism, on many levels and sometimes opposing interests, has also become an important legacy of Little Tokyo. In 1963, the City of Los Angeles began acquiring property for future civic center expansion. Community leaders organized and prepared their own master plan for growth. The Little Tokyo Redevelopment Project was started in 1970, leading to a Little Tokyo Historic District on the north side of First Street and the razing of some buildings to make room for new ones. Groups such as the Little Tokyo People's Rights Organization (LTPRO), Nikkei for Civil Rights & Redress, and the Tuesday Night Project demonstrate an ongoing commitment to the fight for equality and civil rights.

Today Little Tokyo remains a vibrant community with an increasingly diverse population. New condominium developments have brought younger professionals. Casa Heiwa, the Little Tokyo Service Center's affordable housing complex, and senior housing at Little Tokyo Towers boast residents of different ethnicities. The Metro Gold Line provides a new public transportation link while the Japanese American National Museum, Japanese American Cultural and Community Center, Geffen Contemporary at MOCA, and Little Tokyo Library are destinations of interest that draw a wide range of visitors and new life into the neighborhood.

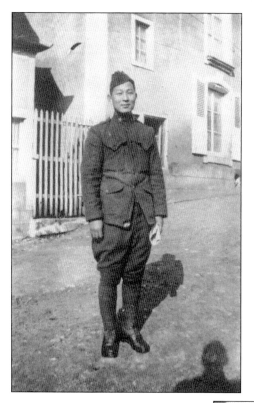

While most of the Japanese Americans who served in World War I came from Hawaii, some were also from the mainland. Hitoshi Fukui, shown here in 1917, served as a soldier in Europe during the war. The son of Fukui Mortuary founder Soji Fukui, Hitoshi completed his basic training at Camp Lewis, Washington. Upon his return to Little Tokyo, he worked at his father's business. (Courtesy of the Fukui family.)

Growing up, Kayoko Wakita lived in a wood-frame fourplex on the west side of Weller Street, located near the New Palace Hotel. Wakita received musical training from her parents, Giichi "Baido" Wakita, who taught *shakuhachi* (bamboo flute), and Nobue, who was a *koto* (a Japanese string instrument) teacher. She became a musician herself by mastering the koto and later played with famed composer Harry Mancini. (Courtesy of the Wakita family.)

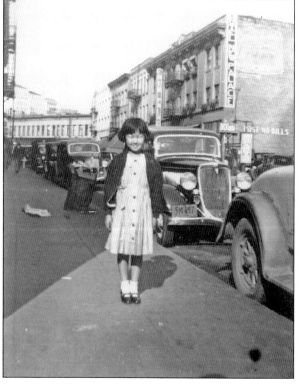

Before moving to Little Tokyo in 1932, the Narasaki family lived in Stockon and West Los Angeles. Miyoko Narasaki leased land from the owners of the Miyako Hotel in the 1930s and opened the Narasaki Hotel, located on San Pedro Street. Hotels were often used as long-term apartments for families. It was a communal space with just one bathroom per floor. Upon returning to Little Tokyo after World War II, Miyoko restarted the Narasaki Hotel on Weller Street until the 1970s, when the land was purchased for the New Otani Hotel. Pictured at right are, from the left, Miyoko Narasaki, Shigeji Ito, Chiyeko (Narasaki) Terakawa, and Wataru Ito dancing in her living room around 1950. The photograph below shows Miyoko Narasaki (far right) with family and friends in her living quarters around 1950. (Both courtesy of Shigeji and Fumie Ito.)

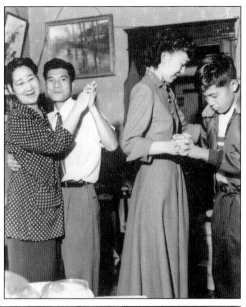

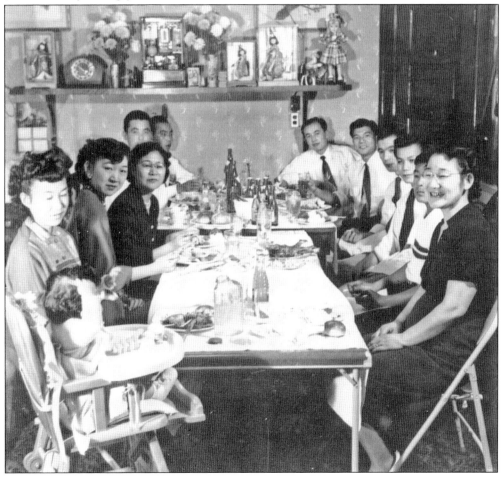

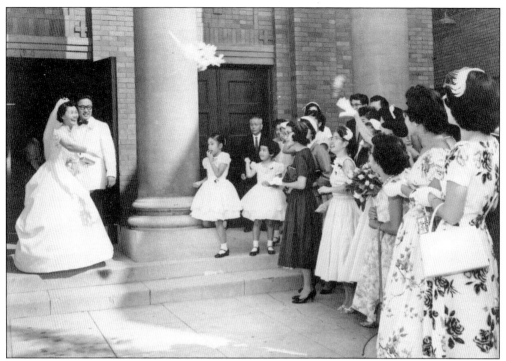

Atsuko Yamaguchi tosses her wedding bouquet to guests after her marriage to Tadashi Kowta at Union Church of Los Angeles on June 23, 1957. The ceremony was officiated by the groom's father, Rev. Sohei Kowta, and Rev. Dr. Paul Waterhouse. (Courtesy of Tadashi and Atsuko Kowta.)

Children are playing on South Hewitt Street in Little Tokyo around 1950. (Courtesy of Robert Kihara.)

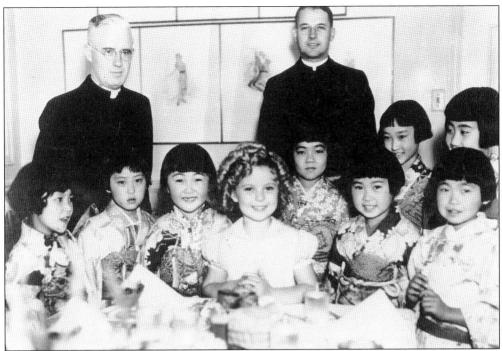

Child star Shirley Temple celebrates her seventh birthday in 1935 with students from Maryknoll School. Fr. Hugh Lavery (right) and Fr. Francis Caffrey (left) were Maryknoll seminary classmates and ordained together in 1924. Father Caffrey arranged for the nisei students to attend this special celebrity birthday. He was Maryknoll's promotion director and made the rounds in the film industry. (Courtesy of St. Francis Xavier Chapel Japanese Catholic Center.)

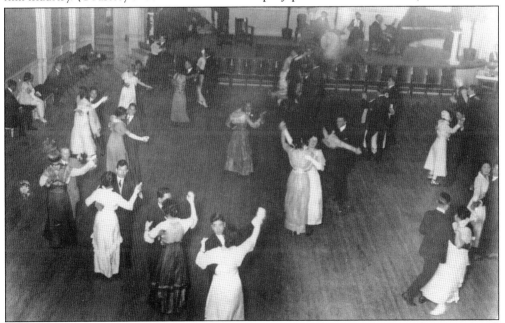

Ballroom dancing was popular among both issei and nisei. Dancers are shown at Blanchard Hall on Broadway Avenue between Second and Third Streets. (Courtesy of Toyo Miyatake Studio.)

Fusako, Kayoko, and Harry Honda recline on the steps of their Bunker Hill home at 707 West Second Street in 1926. In 1913, their house was dedicated as a St. Francis Xavier Home and served as a chapel, clubhouse, and home for Father Breton, a Japanese-speaking Catholic missionary. Father Breton performed the first Japanese Mass in Little Tokyo in 1912. (Courtesy of Harry Honda.)

Fr. Albert Breton and Kozo Fred Ogura, a prominent Catholic businessman, stand with the first class of Maryknoll School students in 1926. Father Breton came to Los Angeles after an issei wrote to the bishop of Hakodate asking to confess and be resolved via registered mail. In 1915, St. Francis Xavier School, a kindergarten, and an English-language night school were established at 133 Hewitt Street. (Courtesy of St. Francis Xavier Chapel Japanese Catholic Center.)

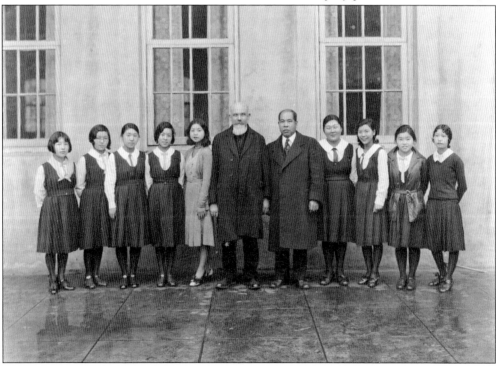

From left to right, Hiroshi "Bill," Keiko, and Takeshi Shishima pose for this 1940 photograph wearing their Maryknoll School uniforms. (Courtesy of Bill Shishima.)

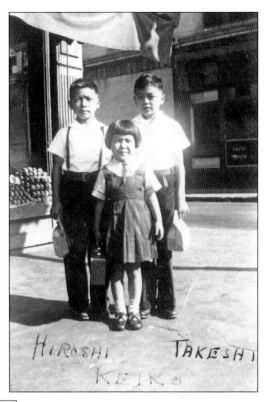

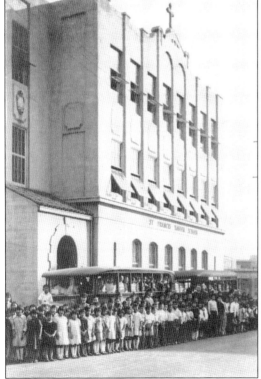

St. Francis Xavier School moved to 226 South Hewitt Street and was renamed Maryknoll School in the early 1920s. Buses transported students between home and school. In 1929, a third floor was added, as seen in this photograph. The school building was razed in the early 1960s. (Courtesy of Harry Honda, from the Mary Poon Collection.)

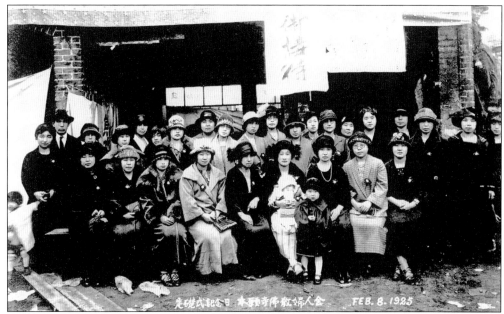

On February 8, 1925, the Los Angeles Hompa Hongwanji Buddhist Temple Fujinkai took this group photograph to acknowledge their service to the community. The Fujinkai regularly acted as hostesses for the temple, providing *o-settai*, a reception, after temple services. (Courtesy of Los Angeles Hompa Hongwanji Buddhist Temple.)

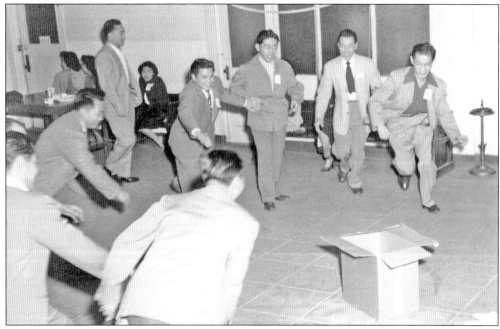

The Los Angeles Hompa Hongwanji's Young Buddhist Association (YBA) was organized for youth to learn about Buddhist teachings and to participate in activities such as temple cleaning and upkeep. They were very popular social organizations that organized community picnics, regional conferences, as well as a variety of competitive sports teams, such as volleyball and basketball. YBAs continue to be active today. (Courtesy of Los Angeles Hompa Hongwanji Buddhist Temple.)

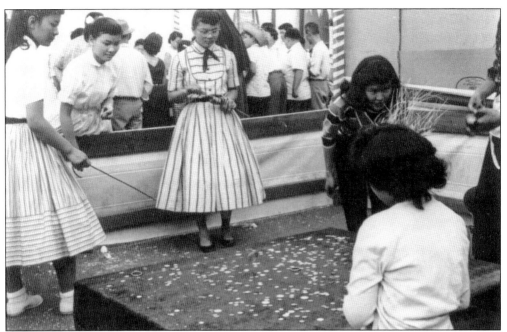

Amy Kawase, Naomi Takeshita, and Genevieve Uyeda are shown playing "Dibs" at the Maryknoll School Carnival in 1957. (Courtesy of Harry Honda.)

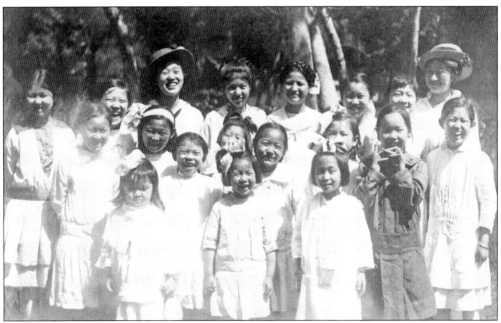

Pictured are the Sunday school teacher and girls from the Japanese Union Church of Los Angeles around 1925. (Courtesy of the Mizushima family.)

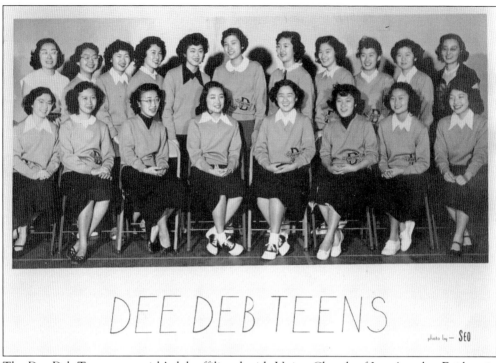

The Dee Deb Teens was a girls' club affiliated with Union Church of Los Angeles. Evident in this group photograph from March 24, 1951, are the distinctive saddle shoes and letterman-style sweaters of the 1950s. Other girls' clubs of this era included the Bluebirds, Blue Circle, Demoiselles, Girls Reserve, Argonauts, Corsairs, Oxy, Hi-Y, Pioneers, and the Knights. (Photograph by Eddie Seo, courtesy of Union Church.)

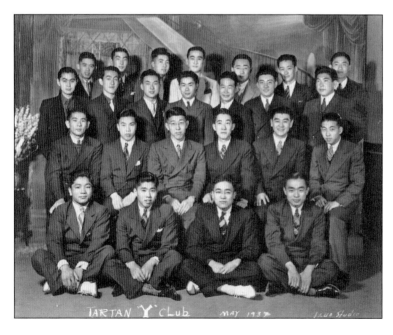

The young men's equivalent of the Dee Deb Teens was the Tartans "Y" Club of Union Church of Los Angeles, photographed here in professional attire in May 1937. Sitting in the second row are, from left to right, Jack Sasaki, Haruo Ishimaru, George Morey, Mareo Masunako, Jack Inouye, and Jim Ishikawa. (Photograph by Izuo Studios, courtesy of Union Church.)

The Girl Scouts of America was another way that young girls in Little Tokyo participated in community service. Maryknoll Girl Scouts are shown here around 1937. (Photograph by Toyo Miyatake, courtesy of Harry Honda.)

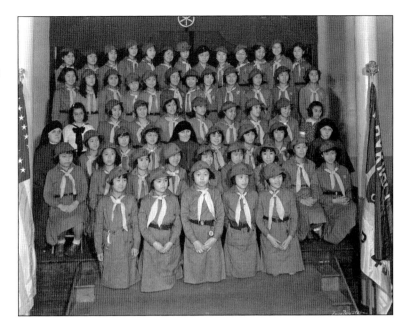

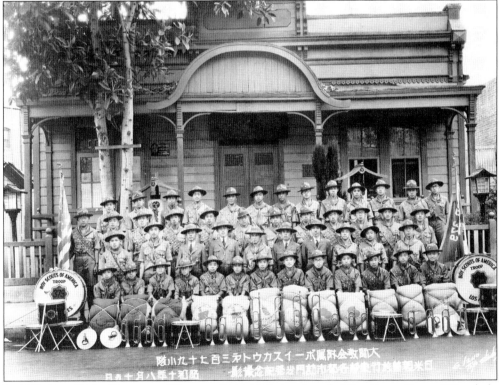

In 1931, Rev. Taido Kitagawa of Koyasan Daishi Mission founded Boy Scout Troop 379 to help bolster against anti-Japanese prejudice that prevailed during the Depression. In 1935, Troop 379 was named an outstanding Boy Scout troop by Pres. Franklin D. Roosevelt. (Photograph by S. Izuo Toyo Studio, courtesy of Mike Murase.)

Zen monks Nyogen Senzaki (right) and Soen Nakagawa visit at the home of Kayoko Wakita around 1950. Senzaki was one of the 20th century's leading proponents of Zen Buddhism in the United States. In Little Tokyo, Senzaki met Kin Tanahashi, who introduced Senzaki to Nakagawa's haiku poetry. Nakagawa eventually became a prominent teacher in his own right, known for his unorthodox style and originality. (Courtesy of the Wakita family.)

Sumio "Jimmy" Tanahashi was born to Soji and Kin Tanahashi in 1923 with severe disabilities. Nyogen Senzaki (in the photograph above) cared for Jimmy and was frequently seen pushing his wheelchair on the streets of Little Tokyo while chanting, "Shu jo mu hen sei gan do." After seven years, Jimmy, who had never spoken a word, was able to say, "Sei gan do." (Courtesy of the Tanahashi family.)

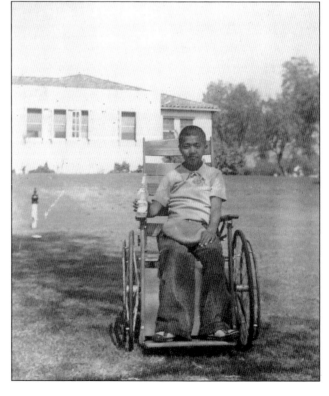

68

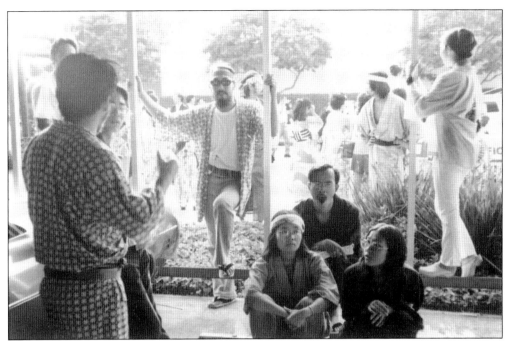

In 1971, there were 31 drug overdoses in the Japanese American community. As a result, the Asian Community Drug Offensive was organized to increase awareness in the community. "Reds," or downers, were the leading cause for most of these deaths, so protests were organized to stop the overproduction of these drugs by Eli Lily Pharmaceuticals. Pictured are Shinuya Ono, Chris Kono, John Ito, Evelyn Yoshimura, George Abe, and Patty Wada. (Courtesy of the Masaoka family.)

In 1970, the Community Redevelopment Agency approached the community with plans for a major mall, hotels, a trade center, and a cultural center. However, redevelopment also meant eviction of longtime family businesses and the loss of affordable housing. The Little Tokyo People's Rights Organization (LTPRO) was formed to advocate for the needs of the residents. This photograph was used in a 1977 LTPRO brochure. (Courtesy of Edward Moreno.)

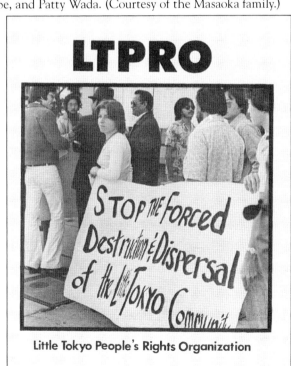

Little Tokyo People's Rights Organization

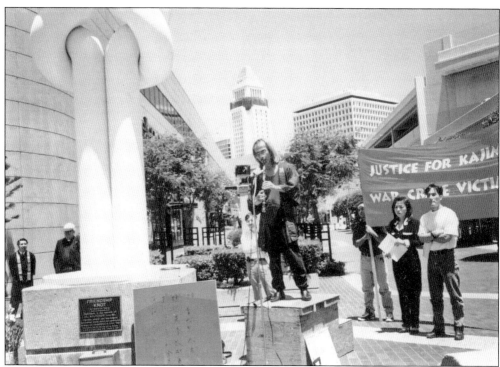

The *Friendship Knot* sculpture by Shinkichi Tajiri, located on Weller Court, was presented to the City of Los Angeles on August 5, 1981. The sculpture was later rededicated to Morinosuke Kajima, chairman of Kajima construction, who had spearheaded redevelopment efforts and whose company developed the New Otani Hotel in efforts to revitalize Little Tokyo. Not everyone, however, shares a positive view of Kajima. In addition to grievances with the company's eviction of residents and businesses during redevelopment, the company's history during World War II is also a point of contention. There was also a bitter dispute between the New Otani Hotel and its workers over the organization of a union. In 1988, the rededication became a point of protest as Nikkei for Civil Rights & Redress joined activists representing Chinese slave laborers and workers from the New Otani Hotel. (Both courtesy of the Masaoka Family.)

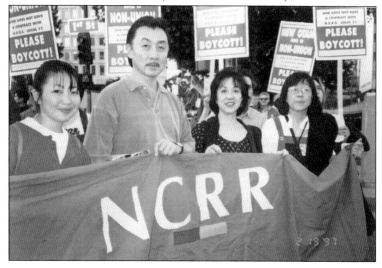

In the early 1980s, a number of groups joined together to build a world-class museum that would share the Japanese American experience as an important part of American history. The Japanese American National Museum opened in 1992 on Central Avenue and First Street on the site of the original Los Angeles Hompa Hongwanji Buddhist Temple. The museum's pavilion building opened in 1999. (Courtesy of JANM.)

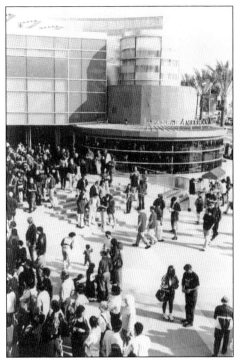

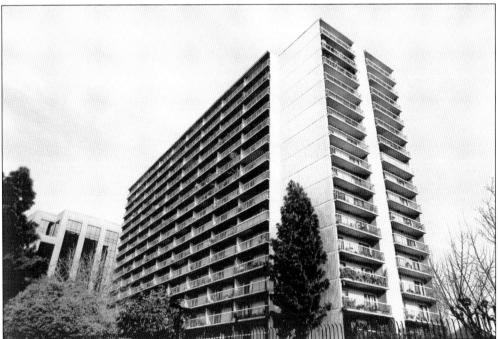

Little Tokyo Towers is a low-income senior housing project sponsored by the Southern California Gardeners' Federation, Japanese American Citizens League, Southern California Christian Church Federation, and the Southern California Buddhist Church Federation. It was built in 1975 as replacement housing for the many old residential hotels that were demolished in the area and had previously housed long-term elderly residents. (Photograph by and courtesy of Jay Ian.)

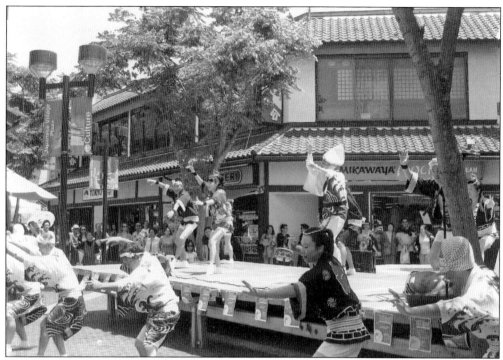

The Japanese Village Plaza opened in 1978 as a part of the redevelopment of Little Tokyo, featuring a yagura fire watchtower on East First Street. Today the plaza is full of specialty shops, bars, restaurants, and a central space for performers. This photograph shows the Awa Odori performance at the 2007 Nikkei Community Day. (Courtesy of Amy Phillips.)

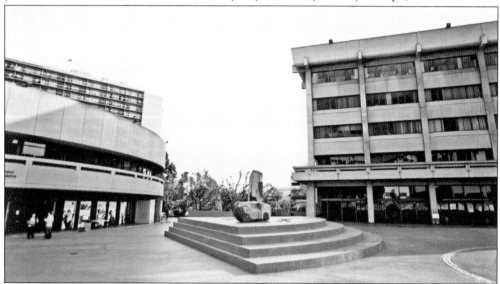

The Japanese American Cultural and Community Center (JACCC) opened in 1980 during the height of redevelopment. JACCC includes a five-story office building that is home to numerous nonprofit organizations, as well as the Aratani/Japan America Theatre, George J. Doizaki Gallery, the James Irvine Japanese Garden, and the JACCC Plaza, designed by artist Isamu Noguchi. (Photograph by and courtesy of Jay Ian.)

David Nagano (left) and Brian Kito work on the "Home is Little Tokyo" mural located on the Japanese Village Plaza parking structure wall on Central Avenue. With the help of 500 people, the mural was completed in 2005. Designed by Tony Osumi, Sergio Diaz, and Jorge Diaz, it tells the history of Little Tokyo from its earliest inception to the present. (Courtesy of Nancy Kikuchi.)

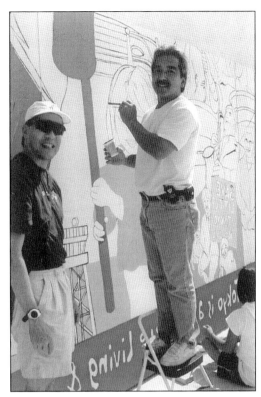

The Little Tokyo/Arts District Metro Gold Line station opened in 2009 on Alameda and First Streets. The elevated and underground light rail travels from Pasadena to East Los Angeles. The station platform was designed by performance artist Hirokazu Kosaka and Ted Tokio Tanaka Architects. (Courtesy of the Community Redevelopment Agency of the City of Los Angeles.)

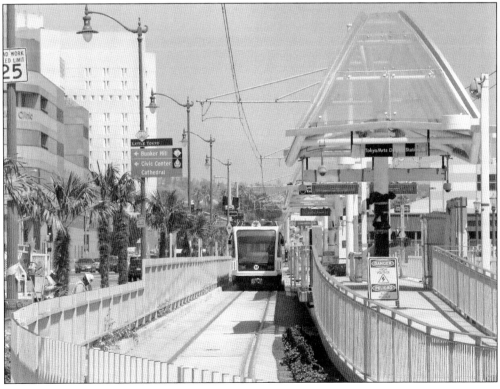

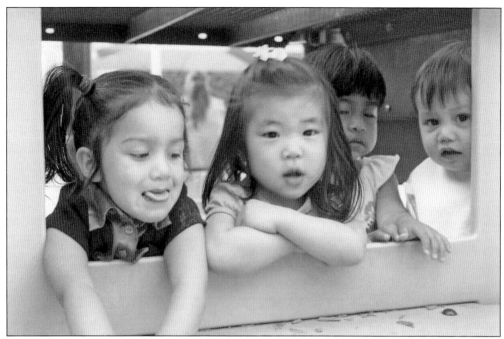

Little Tokyo Service Center (LTSC) is a community-based organization founded in 1979 to serve the residents of Little Tokyo and downtown Los Angeles. It offers a variety of childcare and youth programs, which serve over 150 children each day from infants to age 18. Grace Iino Childcare is located in the Casa Heiwa building at LTSC, and Angelina Head Start Preschool is located at Angelina apartments in Echo Park. Both services are crucial for low-income parents searching for quality, affordable childcare. Students from the University of California, Los Angeles, mentor and tutor youth at Angelina on the weekends with activities ranging from tutoring, arts and crafts, field trips, and sports. (Photographs by and courtesy of Victor Lazo.)

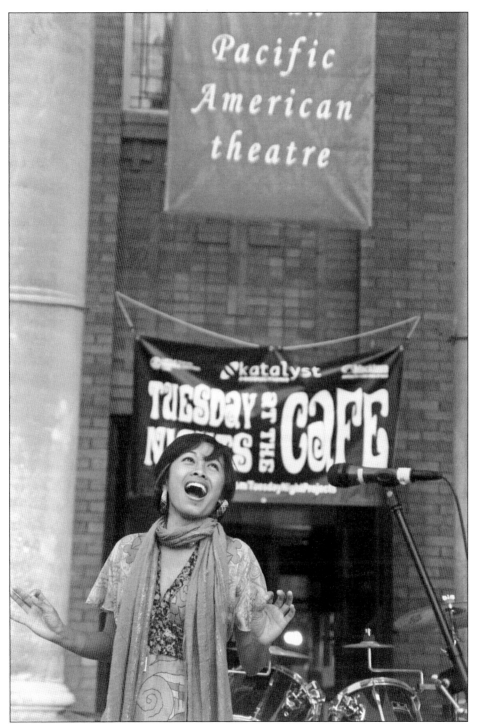

Mary Rose Go performs at the Tuesday Night Café in front of the Union Center for the Arts on Judge John Aiso Street in June 2009. Since 1999, these free events have showcased artists from the Asian Pacific Islander and larger Los Angeles communities and have become a space for artistic, cultural, political, and community action. (Photograph by and courtesy of Michael Nailat.)

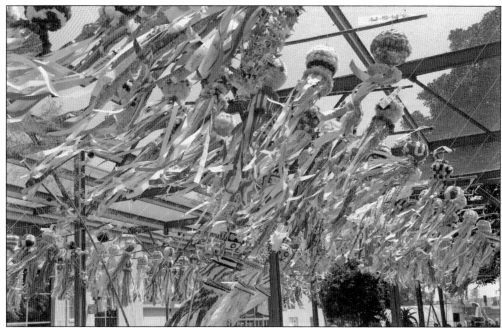

In 2009, the Nisei Week Foundation, the Little Tokyo Public Safety Association, and the Nanka Kenjinkai Kyogikai worked together to present the first annual Los Angeles Tanabata Festival. Various organizations from throughout Southern California made 240 colorful *kazari* (paper ornament streamers) that were hung from rafters at the Geffen Contemporary at MOCA. Ten prize-winning kazari from Sendai, Japan, were also displayed. The festival encourages community groups, schools, businesses, and families to work together to design and make their own kazari, and then to come to Little Tokyo to see their kazari hanging together with all of the rest of the decorations. In the photograph below, Junko Yonezawa teaches Korey Kito how to fold a paper flower. (Photograph above by Richard Fukuhara, courtesy of Richard Fukuhara; photograph below by Shun Kawabe, courtesy of Shun Kawabe.)

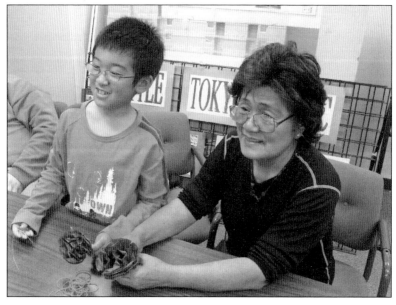

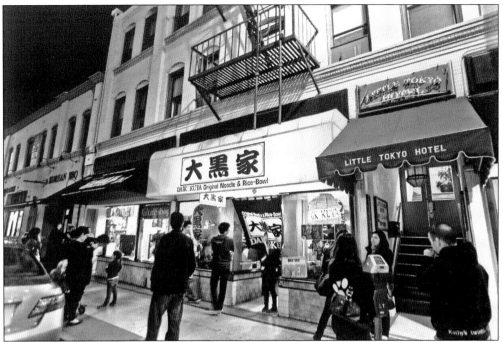

Little Tokyo continues to go through many changes. The development of condominiums, increasing number of Korean business owners and residents, the introduction of chain restaurants and urban establishments, and the many people who come looking for Japanese anime and pop culture items have all brought new energy and demographic shifts. At the same time, younger Japanese Americans are coming on their own with friends to places like Daikokuya on First Street. Known for their ramen, it has lines down the block before it opens. Suehiro is a diner-style Japanese "comfort food" restaurant that uses the Japanese style of displaying plastic food items from its menu. The numerous karaoke bars, stylish clothing shops, coffee bars, art galleries, and yogurt shops have made it a popular daytime and nighttime destination for hanging out. (Photographs by and courtesy of Jay Ian.)

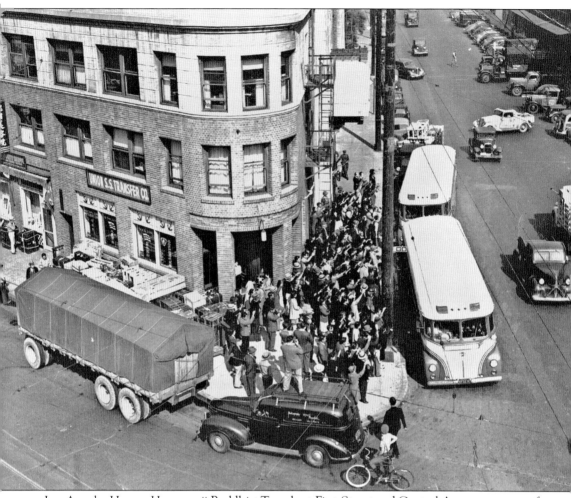

Los Angeles Hompa Hongwanji Buddhist Temple at First Street and Central Avenue was one of the sites where Japanese Americans assembled for forced removal in April 1942. Other sites in Little Tokyo included Maryknoll School and Union Church. (Photograph by Jack Iwata, courtesy of Los Angeles Hompa Hongwanji Buddhist Temple.)

Four

WAR

After Japan's attack on Pearl Harbor on December 7, 1941, Japanese Americans were unjustly seen as the enemy. Pres. Franklin D. Roosevelt signed Executive Order 9066 on February 19, 1942, initiating the forced removal from the West Coast and incarceration of 120,000 people of Japanese ancestry (two-thirds were U.S. citizens) in 10 concentration camps in remote areas of the country. By June 1942, Little Tokyo was a ghost town. The loss of homes and businesses was staggering, and many Japantowns on the West Coast were never reestablished.

In the camps, former Little Tokyo residents created some semblance of normality by reestablishing religious and cultural organizations. On the war front, many Japanese American men volunteered or were drafted to serve in the armed forces despite their families being held behind barbed wire. Tragically, one of Little Tokyo's own, Kei Tanahashi, was among the first nisei officers to die in combat. Meanwhile, African Americans from the South migrated to Southern California in unprecedented numbers to work in the burgeoning defense industry. Barred from living in many areas of Los Angeles, they settled in Little Tokyo. The community was renamed Bronzeville and became home to upwards of 70,000 African Americans.

Although the U.S. government discouraged the reformation of enclaves after the war, former residents gradually made their way back to Little Tokyo, often living in hostels, temples, and churches. Leaders from both the African American and Japanese American communities worked to ease the transition from Bronzeville back to Little Tokyo.

The World War II experience profoundly affected Japanese American awareness of democratic ideals. Beginning in the 1970s, activists fought for redress and reparations to address these injustices. February 19 is commemorated annually in Little Tokyo and other parts of the country with events to educate the public about what happened so that it will never happen again. In the aftermath of the terrorist attacks against the United States on September 11, 2001, many Japanese American organizations spoke out, and a candlelight vigil was organized to show solidarity and support for Muslim and Arab Americans who had become the targets of discrimination.

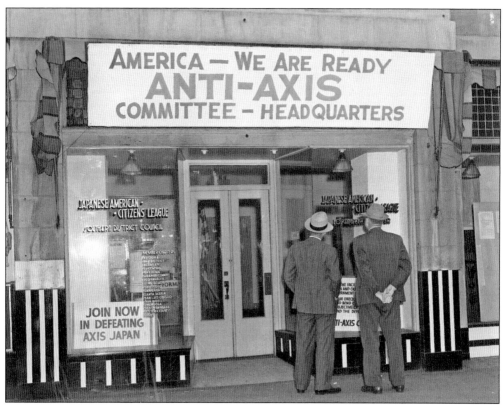

With Fred Tayama as chair, the Japanese American Citizens League (JACL) opened an Anti-Axis Committee office in Little Tokyo as part of its campaign to demonstrate the patriotism and loyalty of Japanese Americans towards the United States. The photograph is dated December 13, 1941. (Courtesy of the *Herald Examiner* Collection/Los Angeles Public Library.)

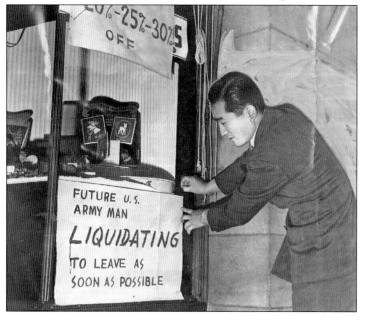

Yasuo Clifford Tanaka posts a sign outside his photography supply store located on San Pedro Street on December 14, 1941. Liquidation sales and auctions forced businesses to lose much of their capital prior to incarceration. Los Angeles mayor Fletcher Bowron and the County Board of Supervisors also dismissed all nisei civil service workers in January 1942. (Courtesy of the *Herald Examiner* Collection/Los Angeles Public Library.)

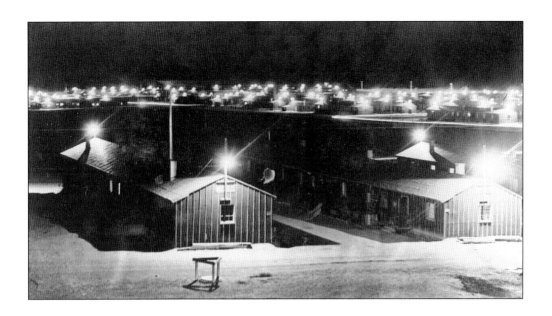

There were 120,000 people of Japanese ancestry sent to 10 concentration camps in desolate areas of the nation. Heart Mountain Relocation Center is shown above sometime between 1942 and 1945. With 11,000 inmates, Heart Mountain had become the third largest "city" in Wyoming during the war. The former Little Tokyo residents persevered and recreated their cultural and religious organizations within the different camps. Protestant churches and Buddhist temples with *obutsudan* (Buddhist altars) made from scrap lumber continued to meet in the tar-papered barracks. Catholic parishes in the camps were given the moniker "Parish of 10,000 Miles," because the Fathers and Brothers would travel from Little Tokyo to the various camps. Maryknoll Church parishioners are pictured below at Heart Mountain in 1943. (Photograph above courtesy of the Tanahashi family; photograph below courtesy of Joe Suski.)

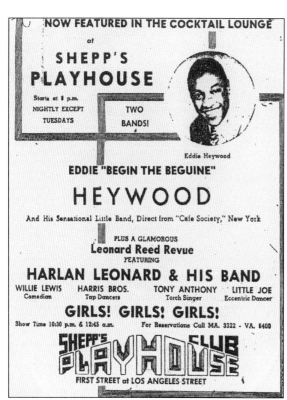

Drawing mixed-race audiences, Bronzeville's nightclubs were part of a string of clubs that extended to Watts, rivaling nightspots near Forty-second Street and Central Avenue. Leonard Reed, a producer of Shepp's Playhouse shows (located at First and Los Angeles Streets), had formerly worked at New York's Cotton Club. Notable performers at Shepp's and other Bronzeville clubs were T-Bone Walker, Charlie Parker, Coleman Hawkins, and Eddie Heywood. (Courtesy of *California Eagle*.)

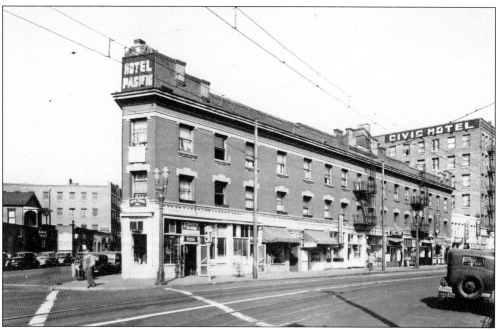

African American entrepreneurs were not new to Little Tokyo. At the turn of the early 20th century, the "Brick Block" (near First and San Pedro Streets) was one of Los Angeles's first black business enclaves. The hotels in this photograph from the late 1940s were on San Pedro Street between First and Second Streets. (Photograph by Archie Miyatake, courtesy of Toyo Miyatake Studio.)

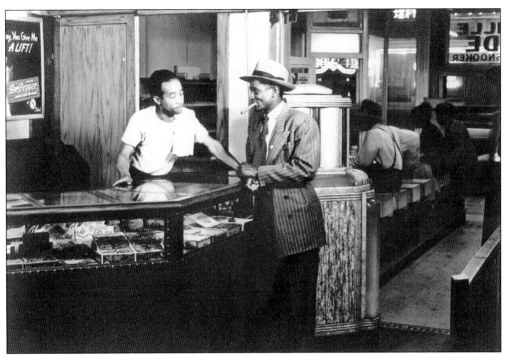

The Bronzeville Arcade, located at 316 East First Street, advertises snookers (a billiard game) at the top right of the photograph above around 1946. Between a coffee shop and the pool hall in the Bronzeville Arcade was a shoe-shine business, seen below. Although 40,000 to 70,000 African American and Latino families lived in Little Tokyo during the Bronzeville era, the community only had housing for 30,000, which led to severe overcrowding. (Photographs by Archie Miyatake, courtesy of Toyo Miyatake Studio.)

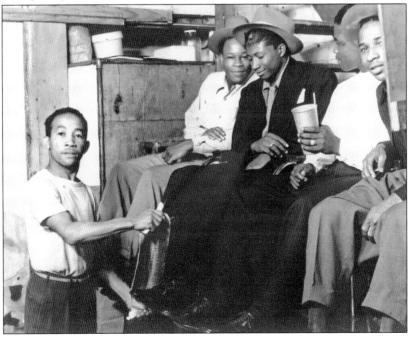

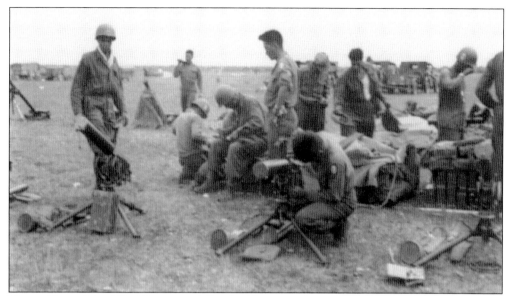

Nisei soldiers of the 442nd Regimental Combat Team are cleaning their weapons in the European Theater around 1944. With its battle cry, "Go For Broke!," the 442nd Regimental Combat Team and the 100th Infantry Battalion earned the distinction of being the most decorated unit of its size and length of service in battle in U.S. military history. (Courtesy of Ted Ohira and the Go For Broke National Education Center.)

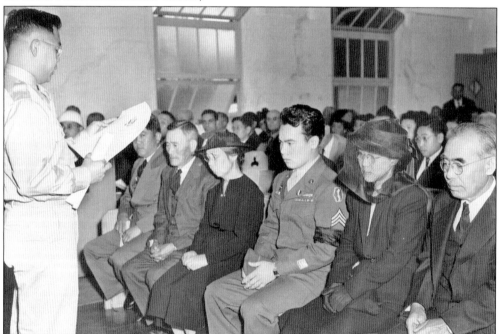

Families of fallen soldiers gather at Maryknoll Church around 1948. Many of the soldiers' remains were not recovered and returned to the United States until the late 1940s. When the coffins arrived at Union Station, photographer Archie Miyatake would go to document families waiting for their deceased sons' caskets. Miyatake recalls mothers weeping in intense grief upon seeing and touching the caskets. (Photograph by Archie Miyatake, courtesy of Mike Murase.)

Second Lt. Kei Tanahashi, whose parents owned and operated Asahi Dye Works on First Street, was killed in action on July 4, 1944, in Castellina, Italy, while serving with the 442nd Regimental Combat Team. He was the first mainland nisei officer to die in combat. (Courtesy of the Tanahashi family.)

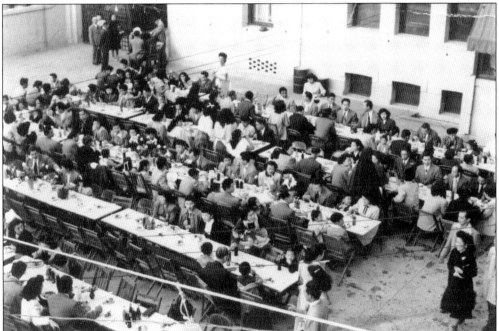

Maryknoll Church parishioners gather for a postwar reunion in 1948. Rev. Sohei Kowta of Union Church, Samuel Ishikawa, and Rev. Harold Kingsley worked to promote the gradual transition of Bronzeville back to Little Tokyo with "Pilgrim House" and the "Common Ground Committee of Caucasians, Japanese, and Negroes." (Photograph by Tomeo Francis Hanami, courtesy of St. Francis Xavier Chapel Japanese Catholic Center.)

Pictured around 1949 are the children of Jose and Rosa Watanabe, formerly of Tarma, Peru. The U.S. government forcibly deported the Watanabe family from Peru, intending to use them as hostages in exchange for American prisoners of war. They were interned at the Crystal City Department of Justice camp in Texas until 1947. The Watanabe family later settled at the Sun Hotel on Weller Street. (Photograph by Igarashi Studio, courtesy of Hector Watanabe.)

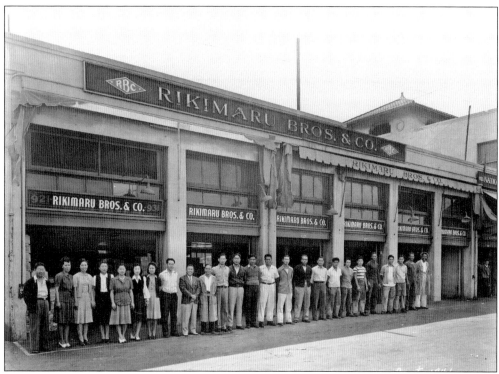

The U.S. government confiscated Rikimaru Brothers Produce Company shortly after the bombing of Pearl Harbor. Isamu Rikimaru's family members were separated while incarcerated in the camps. Told that he would not be reunited with his family until after the war, Rikimaru agreed to go back to Japan with his family aboard the SS *Gripsholm* and unknowingly took part in the prisoner-of-war hostage exchange program between the United States and Japan. (Courtesy of Kazu Rikimaru and the Isamu Rikimaru family.)

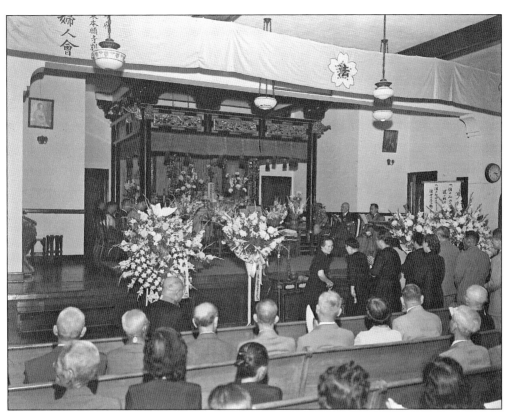

A memorial service for victims of the Hiroshima atomic bomb was held at Higashi Hongwanji Buddhist Temple in August 1951. Koyasan Temple is currently the home of the Hiroshima Memorial Park peace flame, which was carried to Los Angeles from Hiroshima by Mayor Tom Bradley in 1984. The temple holds a Hiroshima and Nagasaki memorial service annually in August. (Photograph by Toyo Miyatake Studio, courtesy of JANM.)

Hiromasa Hanafusa, orphaned by the atomic bombing of Hiroshima, stands with Mrs. Reynolds and Miyoko Matsuhara, an atomic bomb survivor (*hibakusha*), on First Street in 1962. They were part of an atomic bomb peace mission visiting Little Tokyo. (Photograph by Toyo Miyatake Studio, courtesy of JANM.)

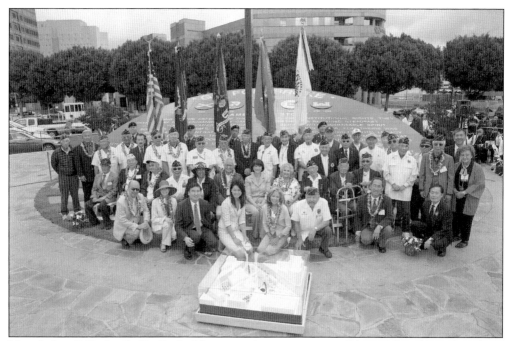

Unveiled in 1999, the Go For Broke Monument honors veterans of the 100th Infantry Battalion, 442nd Regimental Combat Team, 522nd Field Artillery Battalion, 232nd Combat Engineer Company, 1399th Engineer Construction Battalion, Women's Army Corps, and the Military Intelligence Service. Roger Yanagita, AIA, and builder Bruce Kato designed the monument. Veterans also established the Go For Broke National Educational Center. (Photograph by Shane Sato, courtesy of Shane Sato.)

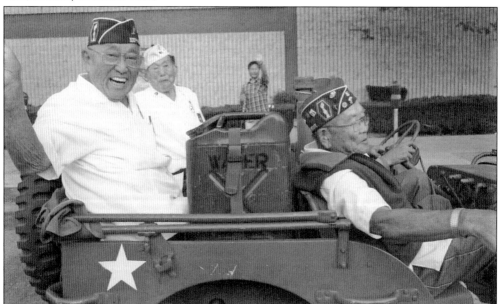

World War II nisei veterans and Go For Broke National Education Center members at the 2009 Nisei Week Festival parade are, from left to right, "Toke" Yoshihashi, James Ozawa, and Don Seki. (Courtesy of the Go For Broke National Education Center.)

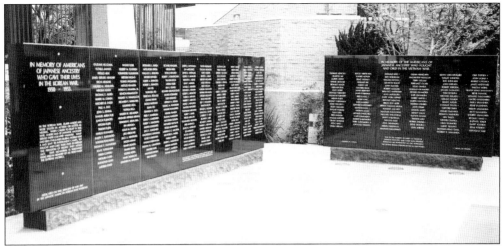

The National Japanese American Veterans Memorial Court, adjacent to the Japanese American Cultural and Community Center located at Third and San Pedro Streets, honors all American soldiers of Japanese ancestry killed in action in Grenada, Vietnam, the Korean War, and World War II. (Photograph by and courtesy of Jay Ian.)

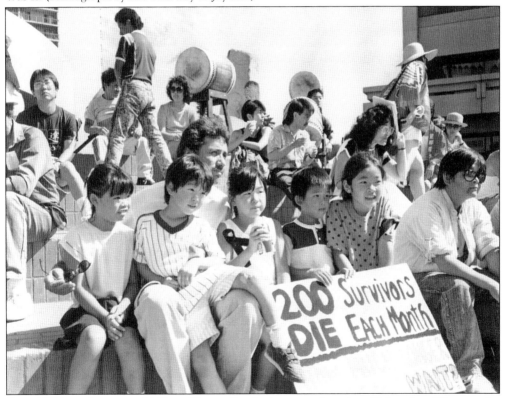

Over 1,000 people came to "A Day of Protest" at the Japanese American Cultural and Community Center Plaza in August 1989, organized by Nikkei for Civil Rights & Redress. The Civil Liberties Act of 1988 had been passed, but Congress had not yet appropriated funding. Speakers included Edward James Olmos, pictured here with, from left to right, Akemi Kondo, Dan Masaoka, Mayumi Masaoka, Reed Wong, and Naomi Iwasaki. (Courtesy of the Masaoka family.)

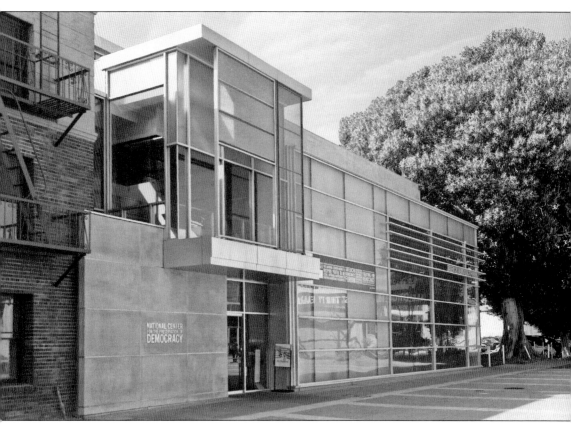

Located adjacent to the Japanese American National Museum's historic building, which was the former Los Angeles Hompa Hongwanji Buddhist Temple, the National Center for the Preservation of Democracy is an educational program of the museum that partners with educators and community-based mentors to inspire youth to become active, informed participants in shaping democracy in America. The Tateuchi Democracy Forum is a venue for presenting panel discussions, presentations, performances, and film screenings. To the right of the building stands the Aoyama Tree, the City of Los Angeles's Historic Cultural Monument No. 920, honoring Rev. Shutai Aoyama and the founding of Koyasan Buddhist Temple. The Moreton Bay fig tree remains a marker of the former site. (Photograph by and courtesy of Alvin Tenpo.)

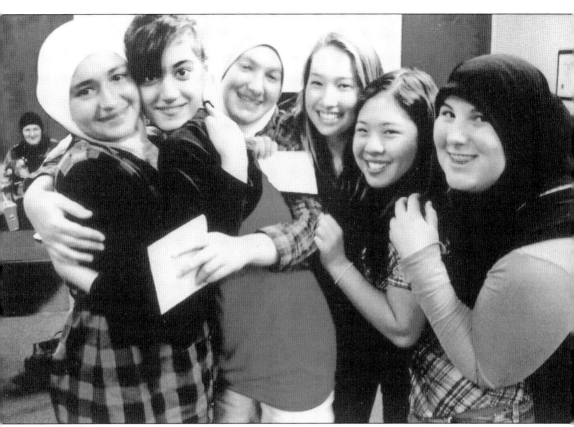

Since the terrorist attacks on September 11, 2001, and the beginning of the War in Iraq, Arab American and Muslim communities throughout the nation have experienced heightened hostility and discrimination due to their ethnicity. The Japanese American Citizens League and Nikkei for Civil Rights & Redress recognized that the civil rights infringements on these communities are similar to those forced on Japanese Americans during World War II. In 2009, these two organizations, in partnership with the Council on American-Islamic Relations and the Islamic Shura Council, launched the Bridging Communities Program to connect youth from the two communities. They continue to meet at various Little Tokyo venues and at a mosque in Orange County. They also participate annually in a pilgrimage to the Manzanar War Relocation Center. Shown here are Muslim American and Japanese American youth at a Bridging Communities session in 2009. (Photograph by and courtesy of Christina Lay.)

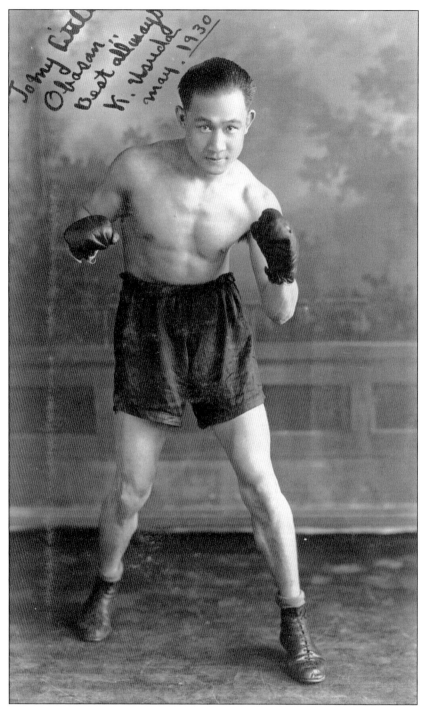

Kintaro Usuda, a welterweight boxer, came to California in 1927. As a Japanese citizen, he was not eligible for the U.S. Olympic team. He competed in the 1928 Amsterdam Olympics for Japan, finishing in fifth place. He later returned to Japan, becoming the 1933 Japanese champion. This photograph was dedicated to Mitsuye Suzuki, a patron and sponsor of many sporting events in prewar Little Tokyo. (Photograph from the Mitsuye Suzuki Collection, courtesy of Mike Murase.)

Five

SPORTS

Sports have played a vital and enduring role in Little Tokyo's history. In the early days of the enclave, participation in sumo (Japanese wrestling), kendo (Japanese fencing), and other martial arts served as important elements of community formation—for participants and viewers alike. Japanese sports provided a means to introduce American-born children to their Japanese heritage, while baseball and basketball became the bridge between the two cultures. Today third, fourth, and later generations of Japanese Americans continue to participate in sports as a way to create community as well as learn about their ancestral heritage.

Little Tokyo produced its own sports heroes. The semipro baseball team Los Angeles Nippons, known as "the Pride of Li'l Tokyo," even played against local non-Japanese semipro teams. In 1931, they went to Japan on a tour to play against Japanese teams. For the issei and nisei, successful athletes from Japan were also sources of pride. The Japanese athletes who participated in the 1932 Olympics in Los Angeles generated feelings of honor and enthusiasm at a time when there were few public role models for the youth in the community.

Japanese American community sports leagues helped immigrants and their families adjust to living in America. For later generations, these leagues foster ethnic and cultural identity and allow families, different generations, and the larger community to remain connected to each other—a link for those who no longer live, work, and play in Little Tokyo. Local boosters help with the Los Angeles Marathon and programs for children, such as Chibi-K: Kids Fun Run. More recently, a community-wide effort to create a sports and activities center called the Budokan of Los Angeles is under development in Little Tokyo. As later generations continue the tradition of sports, identification of Little Tokyo as the historical and cultural heart of the Japanese American community in Southern California endures.

Mitsuye Suzuki, operator of the Pacific Hotel, was an ardent fan and promoter of sports, including sumo and boxing. Affectionately called "sumo no obasan" (sumo auntie), sumo officials turned to her for the final word on the winners. She was included on an FBI list of individuals (dated December 8, 1941) to be arrested and turned over to immigration. (Photograph by Ishikawa Studio, courtesy of Mike Murase, from the Mitsuye Suzuki Collection.)

Kotaro and Hatsuye Yamaguchi are among a large audience watching their son, Takanori Yamaguchi, at a judo tournament. Judo, which means "the gentle way," is a system of wrestling that was developed during the 1880s in Japan and was introduced to Americans in 1903. Judo tournaments continue to be held regularly in Little Tokyo, with participants traveling to the community from other parts of the state. (Courtesy of Masanori Yamaguchi.)

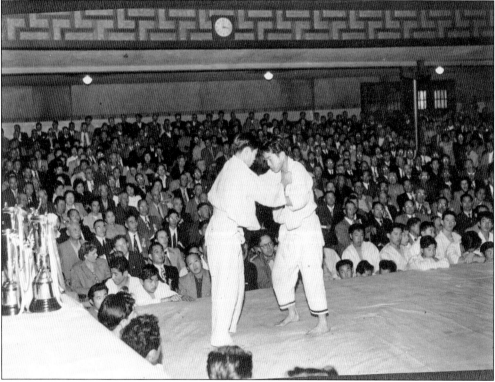

A tour of professional Japanese wrestlers in the early 1900s sparked the popularity of sumo in Southern California. At right, 10-year-old sumo wrestler Masanori Yamaguchi (right) and his opponent make contact in the sumo arena on North San Pedro Street near Jackson Street in 1949. Below, Yamaguchi accepts his prize after winning in the tournament. The tournament arena was razed soon after this tournament to make way for the Parker Center police headquarters. (Both courtesy of Masanori Yamaguchi.)

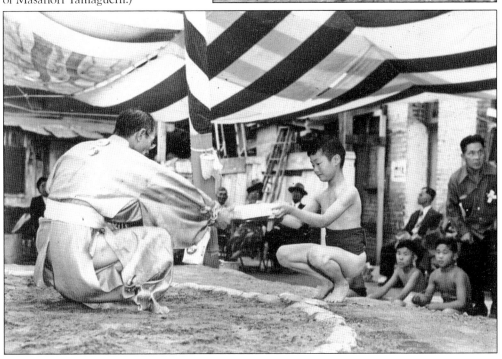

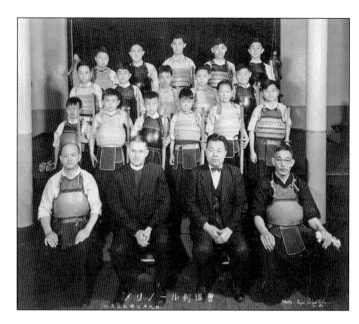

In Los Angeles, the first organized kendo activity emerged in 1914, and by the late 1920s, the majority of participants were nisei. Issei parents encouraged their American-born children to participate in kendo, believing that their children would develop mental toughness, physical strength, and a particular Japanese morality. The Maryknoll kendo team is pictured here with Fr. Hugh Lavery in March 1937. (Photograph by Toyo Miyatake, courtesy of St. Francis Xavier Chapel Japanese Catholic Center.)

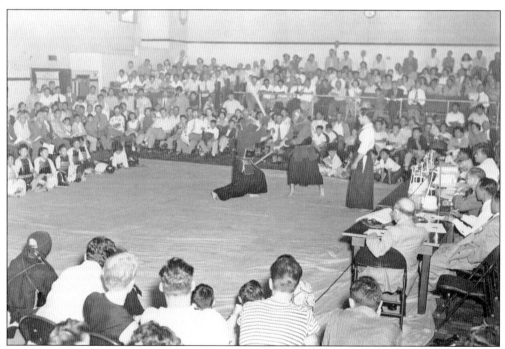

After World War II, kendo was blacklisted as "un-American" because it was linked with Japanese militarism. In the 1950s, a revival occurred when the focus shifted from Japanese morality to a competitive sport. This c. 1960 photograph was taken at a kendo competition at Koyasan Temple. (Photograph by Toyo Miyatake, courtesy of the Japanese Chamber of Commerce of Southern California, History Committee.)

Merchants are shown hanging a banner over Tengen Restaurant. The 1932 Los Angeles Olympic Games were the first time an Asian nation's team competed well against their Western counterparts. Japan sent the second-largest delegation and ranked fifth in the medals. A farewell banquet for the Japanese Olympic team was held at the Biltmore Hotel in downtown Los Angeles. (Photograph by Toyo Miyatake, courtesy of Toyo Miyatake Studio.)

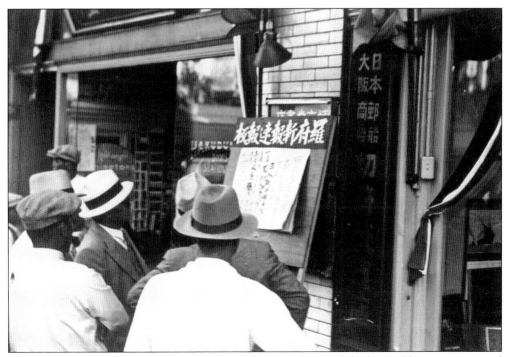

Crowds thronged to Little Tokyo to listen to radio broadcasts of the latest Olympic events and scores. In this photograph, residents read the day's results on a bulletin board posted by the *Rafu Shimpo* outside stores along First Street. The issei and nisei avidly supported the Japanese Olympic team, which set many new records during the games. (Photograph by Toyo Miyatake, courtesy of Toyo Miyatake Studio.)

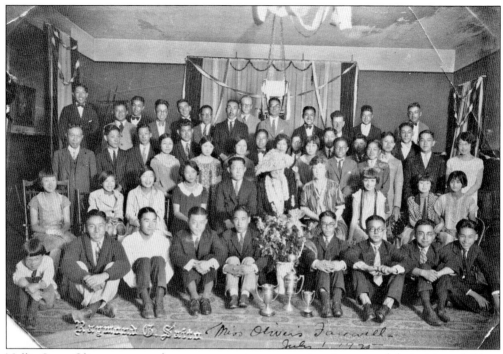

Nellie Grace Oliver was part of a movement to incorporate immigrants and their citizen children into American social and civic institutions. In 1917, she began sponsoring a social and athletic club for local Japanese American youth known as the Oliver Clubs. In this photograph, members attend a 1925 send-off party for Oliver at the Stimson Institute on Hewitt Street before her trip to Japan. (Photograph by Raymond G. Saito, courtesy of Joe Suski.)

This dinner with Oliver members was held at the Nikko Low restaurant around 1920. Nellie Oliver's hat is visible in the back right of the photograph. The first documented nisei youth social club, the Olivers were dedicated to sports, good citizenship, and education. Many members of the Olivers went on to become leaders in their community. (Photograph by Ito Studio, courtesy of Jane K. Urata.)

The amateur Oliver baseball team was champion of the Japanese Athletic Union of Southern California league in 1933. At the same time, a semipro all-star team called the Los Angeles Nippons played from 1926 to 1941. The team included many players from the Olivers. The Nippons, known as the Pride of Li'l Tokyo, were the only semipro team to play against white, black, and nisei teams from other areas. (Courtesy of Joe Suski.)

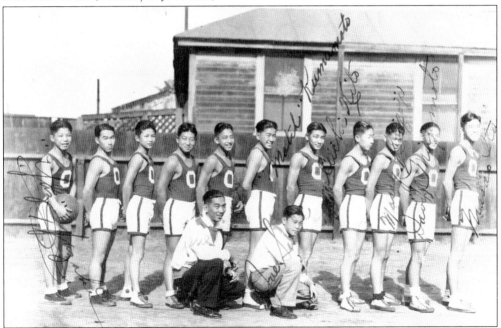

In addition to baseball, the Oliver sports teams excelled in football, basketball, and other sports in Japanese Athletic Union league play. The 1927 Oliver juniors basketball team poses for this photograph at the Stimson Institute/Daiichi Gakuen yard where the teams practiced. (Courtesy of Joe Suski.)

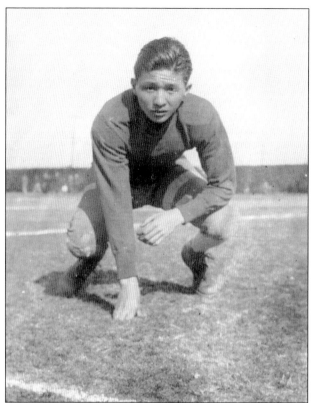

Masao "Joe" Itano played tackle for the Oliver football team from 1932 to 1933. This photograph was taken at the Stimson Institute/Daiichi Gakuen. The Oliver juniors football team had an unbeaten season in 1932. After defeating Southern California teams, the juniors won the intersectional game against the Fresno Mikados 13-0 and then traveled to San Francisco, where they played the Soko Athletic Club to a 0-0 tie. (Courtesy of Joe Suski.)

There was an ongoing, fun, and competitive rivalry between the Central Street Gang and the Turner Street Gang (Turner was later renamed Temple Street). Under the Oliver program, youth in their early teens and younger were brought together to play on the same team. In this 1933 photograph, the Olivers practice their football skills in the Stimson Institute/Daiichi Gakuen yard. (Courtesy of Joe Suski.)

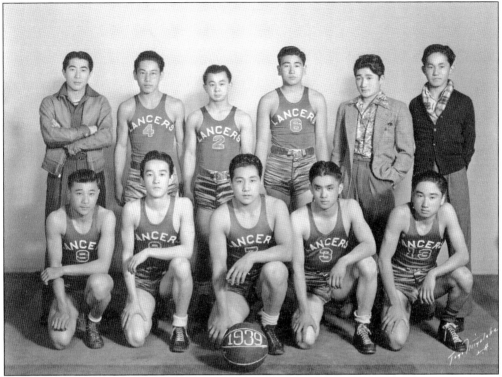

In addition to the Oliver clubs, there were several other local sports teams. The Maryknoll Lancers basketball team competed in the Japanese Athletic Union (JAU) for Little Tokyo's Maryknoll School. Japanese YMCA director Masao Satow organized the league. This 1939 team photograph includes scorekeeper Harry Honda, who would later become a veteran journalist and historian. (Photograph by Toyo Miyatake, courtesy of Harry Honda.)

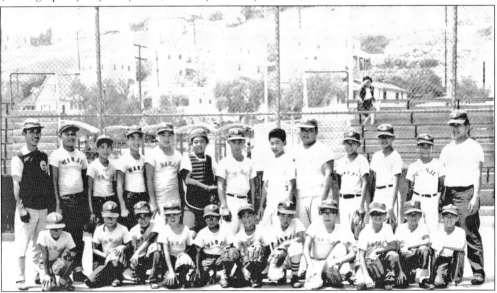

The Wanjis softball team, seen here around 1960, represented the Los Angeles Hompa Hongwanji Buddhist Temple. (Courtesy of Los Angeles Hompa Hongwanji Buddhist Temple.)

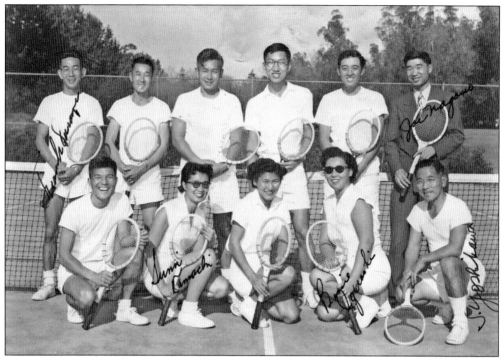

Shigeji Ito (first row, far left) and other Angeles Club "A" League (top ranked) tennis players pose at the net at the 1954 Nisei Week Tennis Tournament. The Angeles Club was the only tennis association in Little Tokyo at the time. Players were ranked in three levels—"A," "B," and "C." (Courtesy of Shigeji and Fumie Ito.)

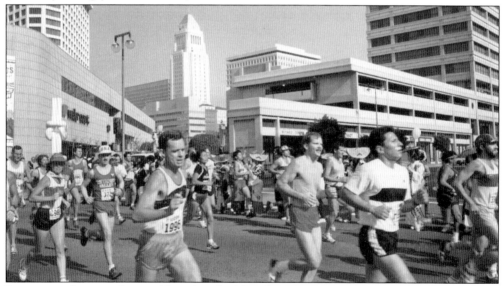

Runners in the second-annual Los Angeles Marathon in 1987 stream past the *Friendship Knot* sculpture by nisei artist Shinkichi Tajiri located at the intersection of Astronaut Ellison S. Onizuka (formerly Weller Street), Second, and San Pedro Streets. There is also a space shuttle Challenger monument in honor of Onizuka. Los Angeles City Hall is pictured in the background of the photograph. (Courtesy of the Tanahashi family.)

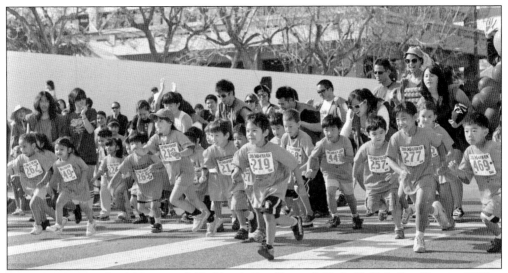

Participants start the 26th annual Children's Day Festival Chibi-K: Kids Fun Run in 2009, a noncompetitive "fun run" routed through the streets of Little Tokyo. Presented by the Japanese American Cultural and Community Center (JACCC), the festival celebrates the Japanese holiday Kodomo no Hi (Children's Day). In 2007, the Chibi-K was revived by youth leaders; many had participated in the event as children. (Courtesy of JACCC.)

Artist's renderings are displayed by Little Tokyo Service Center executive director Bill Watanabe (right) and architect Hayahiko Takase on the future site of the Budokan of Los Angeles. The multipurpose, state-of-the-art sports complex to be constructed in Little Tokyo will bring programs and activities for youth, adults, and seniors into Little Tokyo. Budokan roughly translates into "martial arts hall" in Japanese. (Photograph by and courtesy of Mike Murase.)

Shown in this 1966 photograph is Fujima Kansuma, a legendary teacher of Japanese dance in the United States. Born in San Francisco, she studied kabuki in Los Angeles and Hawaii as a young girl and subsequently under Kikugoro Onoe VI and Fujima Kanjuro in Japan. In 1938, she received her *natori*, or professional name, a rare occurrence for a Japanese American woman. (Courtesy of JANM, Miyatake Studio/*Rafu Shimpo*.)

Six

CREATIVITY

The creative spirit has infused the community of Little Tokyo since its inception. Early immigrants brought with them both a reverence for traditional culture and a curiosity to engage new forms of art. Some people may assume that immigrant communities, forging a new life in America, translates into little time or inclination to pursue cultural activities. Little Tokyo presents a contrary case. Not only did cultural activities—like religion and sports—unite different peoples and generations, it engendered forms of sociability and community. Little Tokyo was home to a substantial number of artists. Even more participated by watching performances or visiting exhibitions.

Traditional Japanese arts flourished. There were teachers of *koto* (a long Japanese zither with thirteen strings), *shamisen* (a three-stringed banjo-like instrument), *shakuhachi* (a bamboo flute), *Noh*, *kabuki*, and *odori* (Japanese dance) who lived in Little Tokyo. Visiting troupes from Japan held performances at the Yamato Hall, Koyasan Temple, and Los Angeles Hompa Hongwanji Buddhist Temple. The popularity of tea ceremony, ikebana, doll-making, Japanese gardens, and bonsai extended beyond Little Tokyo's borders as Japanese Americans became important cultural bridges. Traditional arts were one way for Japanese Americans to stay connected to their ancestral heritage, and many of the nisei generation became prominent artists in the field. But not all Japanese American artists worked in traditional styles. Many pushed the boundaries to work at the forefront of contemporary art forms.

The visual arts and poetry may represent more solitary artistic pursuits, but numerous poetry clubs and artist societies in Little Tokyo provided venues for exchange and debate. In the pre–World War II period, the Japanese Camera Pictorialists of California and photographer Toyo Miyatake exhibited their work internationally, as did the painters of the Shakudo-sha. Today Little Tokyo remains a vital site of art production and display. Many artists—now of different ethnicities and backgrounds—continue to live and work in the community. In addition, there is a wealth of institutional resources. The Japanese American Cultural and Community Center, Aratani/Japan America Theater, Japanese American National Museum, East West Players, and Visual Communications continue Little Tokyo's creative traditions.

The Los Angeles Hompa Hongwanji Buddhist Temple on First Street and Central Avenue played host to cultural activities in addition to religious services. In this prewar concert, Japanese music is celebrated with koto, shamisen, and shakuhachi. Notice the presence of both the Japanese military and national flags hanging in the background. (Courtesy of Tadashi and Atsuko Kowta.)

Hamejiro Hamano accompanies his shamisen teacher, Chujiro Aochi, at Koyasan Daishi Mission around 1930. *Gidayu* is a classical form of Japanese music using shamisen and chanting. In Little Tokyo, it could be heard as a concert or as narration for kabuki at Yamato Hall or the Koyasan Daishi Mission on Central Avenue. Hamano and his brothers started Umeya Rice Cake Company in Little Tokyo in the 1920s. (Courtesy of June Aochi Berk.)

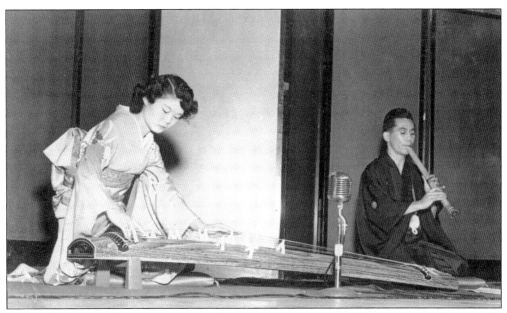

Atsuko Yamaguchi Kowta commenced koto lessons at age five. When war forced her family to Manzanar, she continued to study under Madame Keiko Kikusome and later with Madame Chihoko Nakashima. The Japanese arts were important for the Yamaguchi family. Her father Kotaro was an accomplished shakuhachi player, and her mother Hatsuye was known for ikebana and Japanese dolls. Here Kowta plays alongside Hogetsu Nomura in the 1950s. (Courtesy of Tadashi and Atsuko Kowta.)

Origami became increasingly popular in the postwar period. When noted Japanese origami artist Toyoaki Kawai was invited to demonstrate at the New York World's Fair in 1965, he stopped in Los Angeles, where the Little Tokyo community was known for providing a warm welcome to visiting Japanese cultural and business leaders. (Courtesy of JANM, Miyatake Studio/*Rafu Shimpo*.)

Japanese Americans practiced the classical dramatic forms of Noh and its humorous counterpart, *kyogen*. Master sensei Setsuyo Kita of the Kita School of Noh in Japan visited Los Angeles in 1968, drawing students from throughout North America. Miss Moreland, a specialist in Noh who taught in the University of British Columbia theater department, is shown here taking lessons. (Courtesy of JANM, Miyatake Studio/*Rafu Shimpo*.)

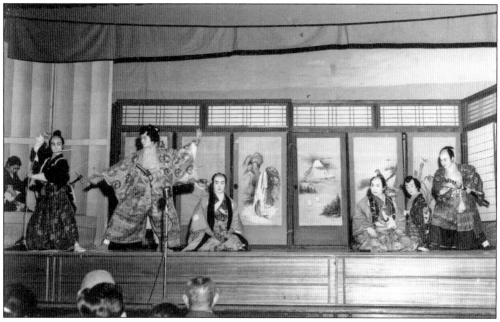

The Koyasan Temple became a popular venue for kabuki performances. This photograph from the 1950s shows actors in full traditional makeup and costume accompanied by shamisen and singers at the left. It was unusual for Japanese dramatic arts to be showcased in mainstream venues, so Little Tokyo became a prominent place to experience Japanese performances. (Courtesy of June Aochi Berk.)

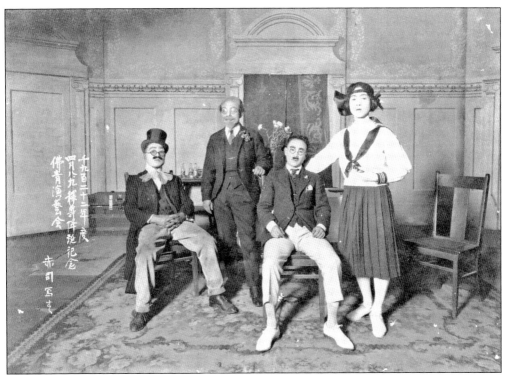

Based on the model of the YMCA, the Young Men's Buddhist Association (YMBA) provided a social outlet for the younger generation with sports activities, the arts, and service to the congregation and the community. The YMBA of the Nishi Hongwanji Buddhist Temple is shown staging a Western-style theatrical performance in 1921. Notice that the young "woman" on the right is actually a man. (Courtesy of Los Angeles Hompa Hongwanji Buddhist Temple.)

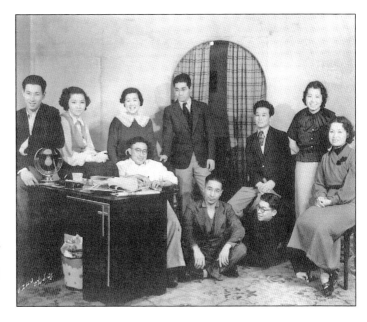

Western theatrical traditions were popular in Little Tokyo, especially among the nisei generation who organized performances, such as the Li'l Tokio Players from 1933 to 1939. The enterprising thespians did everything from writing scripts to designing sets, lighting, costumes, and makeup. Their performances drew upwards of 250 people. Among their collaborators were young nisei trained in theater, art, design, and filmmaking. (Courtesy of Michael Yonemitsu.)

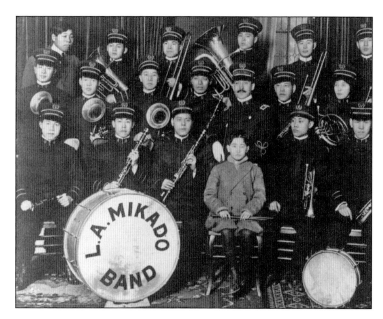

L.A. Mikado Band featured issei from Little Tokyo. Noted photographer Toyo Miyatake joined the band as a saxophonist, though he does not appear in this photograph, suggesting it is from the early part of the 1910s. Miyatake's good friend, Seiichi Nako (first row, far right), appears with a trumpet. The European American man with a mustache was likely the band director. (Courtesy of Toyo Miyatake Studio.)

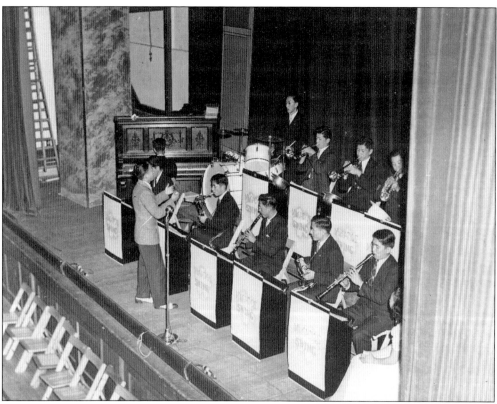

Swing music was very appealing to young nisei. The Mikado Swing Band, shown in this 1940 photograph, is performing at a Nisei Week talent show held at Yamato Hall. During World War II, swing music would affect nisei in profound ways, bringing them joy while incarcerated in remote concentration camps. (Courtesy of Harry Honda.)

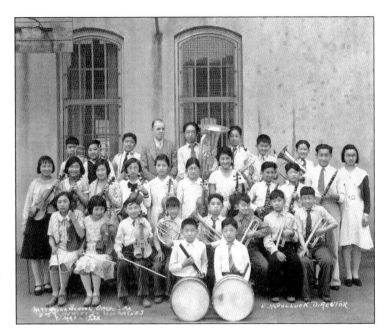

At the Maryknoll School at Second and Hewitt Streets, students were encouraged to become involved in extracurricular activities, including the arts. By November 1922, there were 200 children enrolled. This May 1932 photograph shows the school orchestra, directed by E. M. Pollock, with students proudly holding their instruments. (Courtesy of Harry Honda.)

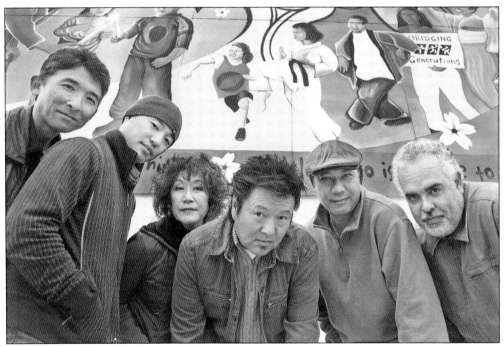

The jazz-fusion band Hiroshima was founded in 1974 by Dan Kuramoto to give voice to the Japanese American experience. Closely tied to the burgeoning Asian American movement, Hiroshima featured classical koto by June Kuramoto and taiko by Johnny Mori. This 2006 photograph shows, from left to right, Danny Yamamoto, Shoji Kameda, June Kuramoto, Dan Kuramoto, Kimo Cornwell, and Dean Cortez in front of the Little Tokyo mural. (Photograph by and courtesy of Jaimee Itagaki.)

The rear yard of Toyo Florist at 113 North San Pedro Street was home to an extensive Japanese garden that was already in place when Toshiyuki Okamura, also an accomplished poet, bought the shop from T. Maeda in 1940. The garden, shown here in 1940, featured a stone lantern, lotus-filled pond, bridge, and teahouse. Japanese gardens were extremely popular in Little Tokyo and beyond. (Courtesy of the JANM, Okamura family.)

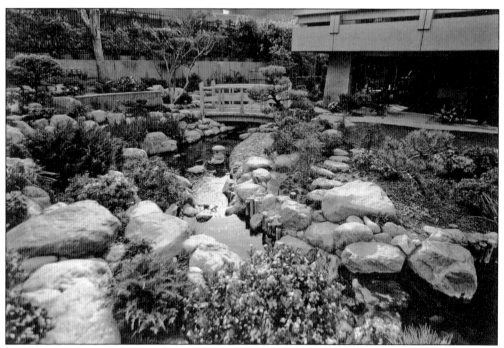

The award-winning James Irvine Japanese Garden (Seiryu-en, or Garden of the Clear Stream) was designed by Takeo Uesugi and completed with volunteer help from the Southern California Gardeners' Federation in 1979; it was renovated in 2009. Shown in this 2010 photograph, it is located between the Japanese American Cultural and Community Center and the Aratani/Japan America Theater. (Photograph by and courtesy of Jay Ian.)

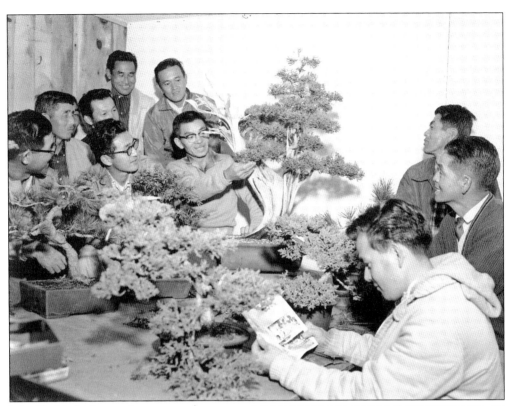

John Yoshio Naka was instrumental in spreading the art of bonsai to the Western world. Born in Colorado in 1918, Naka learned about bonsai from his grandfather in Japan. Upon returning to America, he founded the California Bonsai Society in 1950 and authored many influential books on bonsai. This 1962 photograph shows Naka with some of his colleagues and students. (Courtesy of JANM, Miyatake Studio/*Rafu Shimpo*.)

Ryozo Kado, an issei landscaper, was also a master of *faux bois*, the art of sculpting naturalistic wood shapes in concrete. This 2010 photograph shows the grotto he created at Maryknoll that was inspired by the Lourdes grotto in France. At Manzanar, Kado created faux bois throughout the camp. After the war, he continued his artistry throughout Southern California. (Photograph by and courtesy of Jay Ian.)

As the leading authority on *chado* (the Japanese way of tea) in the United States, Sosei Matsumoto greets the visiting headmaster of the Urasenke School of Tea in Japan in 1956. Born in Hawaii, Matsumoto was trained in Kyoto and is credited with popularizing tea ceremony in postwar America. Her husband Eddie built the tearoom at their Los Angeles home for her classes. (Courtesy of JANM, Miyatake Studio/*Rafu Shimpo*.)

This photograph of a traditional ikebana arrangement is by Japanese American photographer T. K. Shindo, a member of the prewar Japanese Camera Pictorialists of California whose work was shown internationally and is part of the collection of the Los Angeles County Museum of Art. The photograph, likely from the postwar period, demonstrates the connections among different parts of Little Tokyo's creative community. (Courtesy of Tadashi and Atsuko Kowta.)

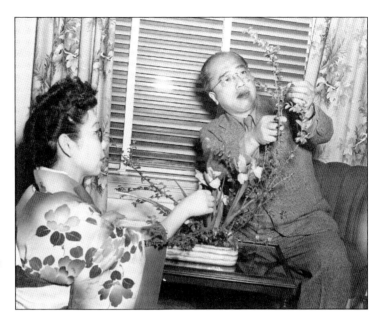

Sofu Teshigahara was the charismatic founder of the Sogetsu School of Ikebana in Japan, who sought to transform ikebana into a form of contemporary expression by using dramatic scale and unconventional materials. He is shown creating a more traditional arrangement at the Miyako Hotel in Little Tokyo in 1951. Mrs. Ishikawa, the wife of the then owner of the hotel, assists. (Courtesy of JANM, Miyatake Studio/*Rafu Shimpo*.)

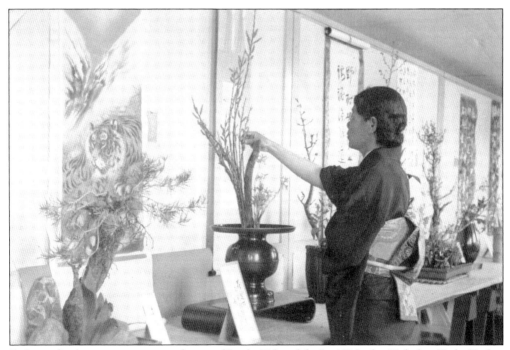

Ikebana displays were an integral part of Little Tokyo life. In 1938, the Hokubei Kado Kyokai was formed to support ikebana teachers and students. Many continued the art form in the World War II American concentration camps despite limited resources. Hatsuye Yamaguchi, seen here in the 1960s, learned ikebana before the war while incarcerated at Manzanar and continued to practice for the rest of her life. (Courtesy of Tadashi and Atsuko Kowta.)

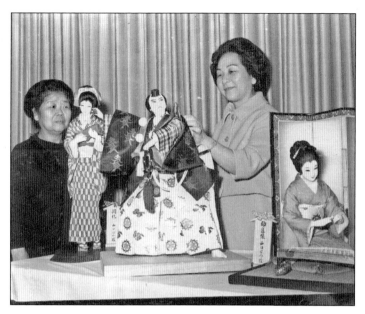

Hatsuye Yamaguchi practices the complex art of *sakura ningyo*, or Japanese decorative doll-making. In this traditional art form, each hair on the doll is individually planted, while breasts, hips, knees, elbows, and even belly buttons are carefully crafted, though they may not be visible. Yamaguchi was a president of the Doll Making Association and a frequent exhibitor at the Nisei Week Festival and elsewhere. (Courtesy of Tadashi and Atsuko Kowta.)

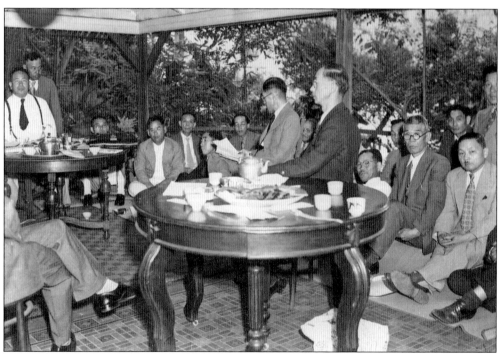

The Agosto Sha poetry club poses in 1940 at Toshiyuki Okamura's Japanese garden at 113 North San Pedro Street. Under the pen name of Boshicho, Okamura was a well-regarded *kaiko* (free style haiku) poet who founded the club with Shimon Kushiyama in 1924. Although to outsiders many Japanese immigrants appeared to be mere tradesmen or tenant farmers, they also engaged in creative pursuits. (Photograph by Toyo Miyatake, courtesy of the JANM, Okamura family.)

Karuta is a Japanese card game where players must quickly match passages of poetry with colorfully rendered images on the card's face. It requires erudition, quick thinking, and dexterity. The 1922 California Championship Karuta Contest, sponsored by the *Japanese Daily News*, shows a range of ages. (Courtesy of the Wakita family.)

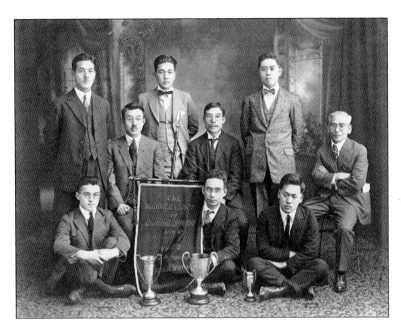

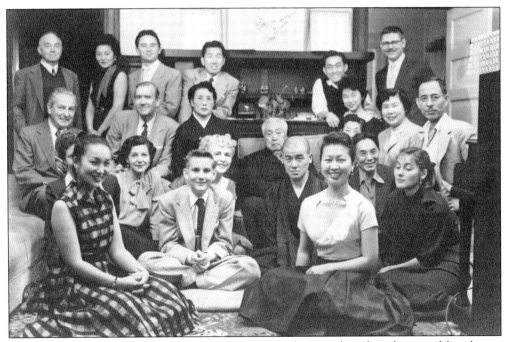

Artists, designers, architects, writers, and musicians have gathered at the monthly salon at Giichi and Nobue Wakita's uptown home on South Kenmore Avenue. Among the luminaries in this 1957 photograph are artists Sueo Serisawa and Kango Takamura, concert pianist Vera Radcliffe, author and Zen priest Nyogen Senzaki, architects Osamu Wakita and George Foy, poet Paul Reps, and NBC art director Milt Waltman. (Photograph by Ikuo Serisawa, courtesy of the Wakita family.)

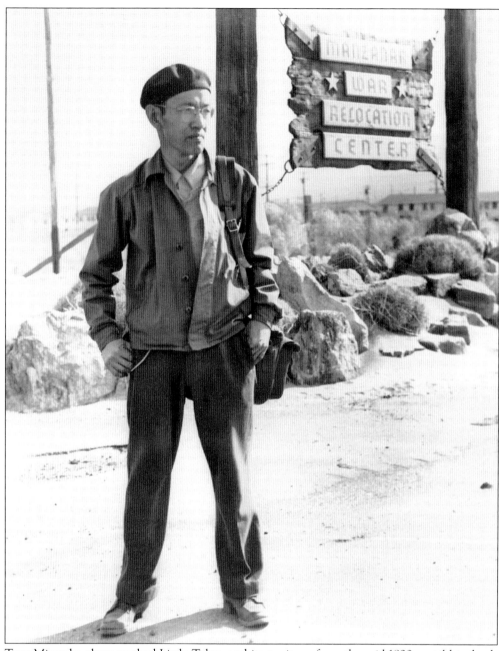

Toyo Miyatake photographed Little Tokyo and its environs from the mid-1920s until his death in 1979. Before the war, his photography studio served as a de facto salon for Little Tokyo's intelligentsia. He smuggled a lens and film plate into Manzanar where he documented camp life, secretly and then with permission. Tokyo Miyatake Studio has continued after his death under the leadership of son Archie and now grandson Alan. (Courtesy of Toyo Miyatake Studio.)

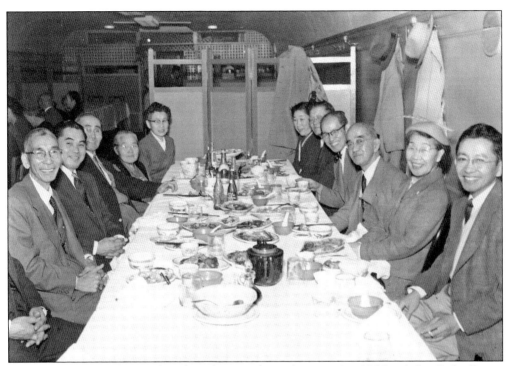

Harry Shigeta opened his Little Tokyo photography studio in 1918 at 206 South San Pedro Street, where he also taught classes. Toyo Miyatake was among his students. Shigeta moved to Chicago, where he became a prominent advertising photographer. This 1955 reunion at Lem's Café on East First Street shows Miyatake fourth from the right. Shigeta is seated next to him. Archie Miyatake is at the far right. (Courtesy of Jane K. Urata.)

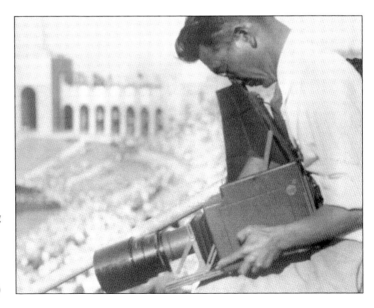

J. T. Sata was a member of the Japanese Camera Pictorialists of California (JCPC), a Little Tokyo–based group of photographers dedicated to exploring the artistic potential of the medium. His award-winning photographs were exhibited internationally in the prewar period. This self-portrait was taken during the 1932 Olympics, a popular subject for members of the JCPC. (Photograph by J. T. Sata, courtesy of JANM.)

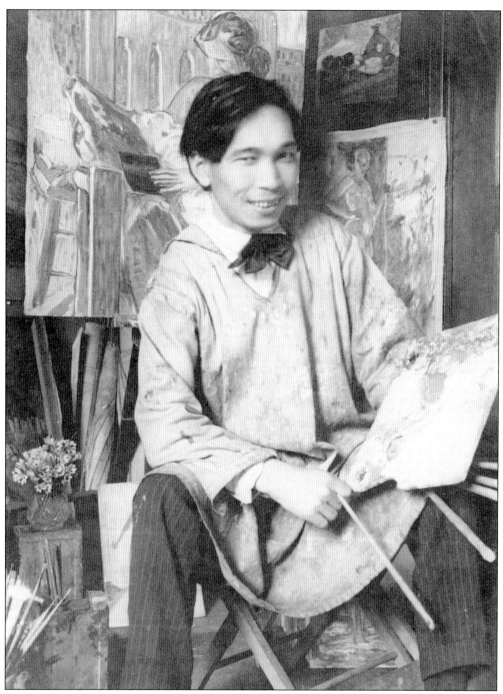

Kinishi Nakanishi painted in an Impressionist style and exhibited at the California Art Club where he became a member in 1920. Also associated with the Arts Students League, he exhibited throughout California while holding a job at the Iwata photography studio at 256 East First Street. When this 1925 portrait was taken, he was residing at the Honda family home on 707 West Second Street. (Courtesy of Harry Honda.)

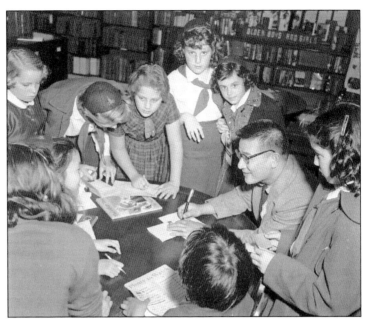

Painter and writer Taro Yashima talks to children at the Los Angeles Public Library in 1955. Yashima came to America in 1939 to study painting, but with the outbreak of war he joined the U.S. Office of Strategic Services. He later became known for his popular children's books, including *Crow Boy* (1956), *Umbrella* (1958), and *Seashore Story* (1967), all of which received the Caldecott Honor. (Courtesy of JANM, Miyatake Studio/*Rafu Shimpo*.)

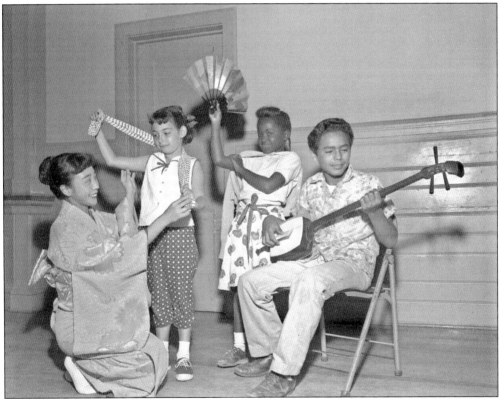

Traditional Japanese performing arts were frequently used to promote cross-cultural understanding. Young children of different heritages participate in the July 1955 Friendship Day camp in Griffith Park where they learned about odori (Japanese dance), shamisen, and Japanese culture from a kimono-clad Azuma Harunobu. (Courtesy of JANM, Miyatake Studio/*Rafu Shimpo*.)

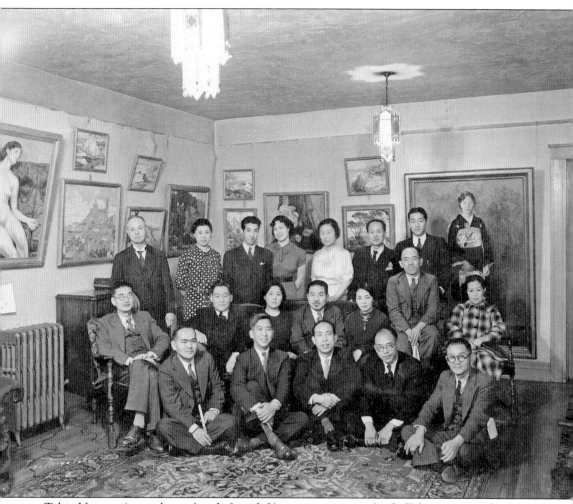

Tokio Ueyama (second row, fourth from left) was a prominent Little Tokyo painter who found inspiration in the work of European masters of the 19th century. Trained at the Pennsylvania Academy of Art and the University of Southern California, his paintings were exhibited nationally in the pre–World War II period. He also cofounded the prominent art group Shakudo-sha, which sponsored exhibitions of their own art and others such as famed photographer Edward Weston. The kimono-clad woman in the full-length portrait is his wife, Suye (second row, fifth from left). This photograph was taken by Ueyama's good friend Toyo Miyatake, and it likely documents the painter's 1936 exhibition at the Miyako Hotel. During World War II, Ueyama taught art while incarcerated at Amache. After returning to Little Tokyo, he and his wife opened the Bunka-Do store, which remains in business on East First Street. (Courtesy of JANM, Okamura family.)

On December 7, 1941, the paintings by Little Tokyo–raised Sueo Serisawa were the subject of an exhibition at the Los Angeles County Museum and featured in the *Los Angeles Times*. After the war, he continued to receive accolades for his art. In 1955, Glen Seno of Japan Airlines's Los Angeles office and Teiho Hashida, Japanese section editor of the *Rafu Shimpo*, examine Serisawa's art. (Courtesy of JANM, Miyatake Studio/*Rafu Shimpo*.)

Isamu Noguchi supervises the installation of his large-scale sculpture, *To the Issei*, in the plaza that he designed for the Japanese American Cultural and Community Center in 1982. The sculptor was born in Los Angeles in 1904 to a European American mother and Japanese poet father, Yone. Throughout his life and art, Noguchi navigated the divide between Japan and the West. (Courtesy of Bill Watanabe.)

Mike Kanemitsu's abstract paintings and association with New York Abstract Expressionists were legendary. When he moved to Little Tokyo in the post–World War II period, he was a charismatic presence in the Los Angeles art world where he pushed the boundaries of printmaking while working at June Wayne's Tamarind Lithography Workshop. (Courtesy of Nancy Uyemura.)

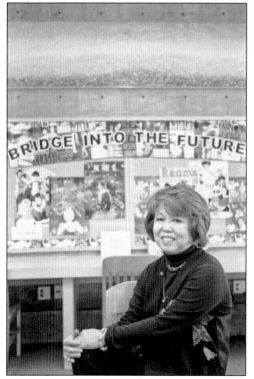

Works of public art dot the landscape of Little Tokyo. A long-time resident of the Arts District adjacent to Little Tokyo, Nancy Uyemura is responsible for two major pieces: the entrance to Casa Heiwa on East Third Street and an interior sculpture at the Little Tokyo branch of the Los Angeles Public Library, seen here in 2010. (Photograph by and courtesy of Jay Ian.)

East West Players is the preeminent Asian American theater company. Established in 1965, they moved to the Union Center for the Arts in 1998. The site, developed by the Community Redevelopment Agency in the former Union Church on North San Pedro Street (now Judge John Aiso Street), also houses Visual Communications, an Asian American media arts organization founded in 1970, and LA Artcore Gallery. (Courtesy of the Community Redevelopment Agency of the City of Los Angeles.)

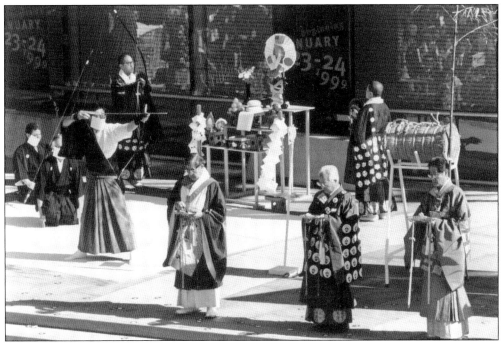

Hirokazu Kosaka is an avant-garde performance artist who trained at Chouinard Art Institute, an ordained Buddhist priest in the Shingon tradition, a master archer, and the visual arts director of the Japanese American Cultural and Community Center. Kosaka is shown performing Japanese archery at the grand opening of the Japanese American National Museum's Pavilion in 1999. (Photograph by Bart Bartholomew, courtesy of JANM.)

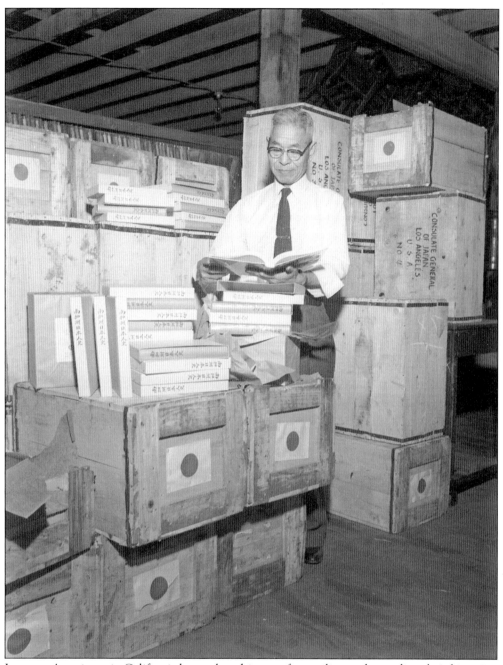

Japanese Americans in California have a long history of compiling and recording their histories. Masami Sasaki is shown examining copies of *Minami Kashu Nihonjinshi*, or *The History of Japanese in Southern California*, published by the Nanka Nikkeijin Shogyo Kaigisho in 1956. The book was written entirely in Japanese and contains over 30 photographs of local history. (Courtesy of JANM, Miyatake Studio/*Rafu Shimpo*.)

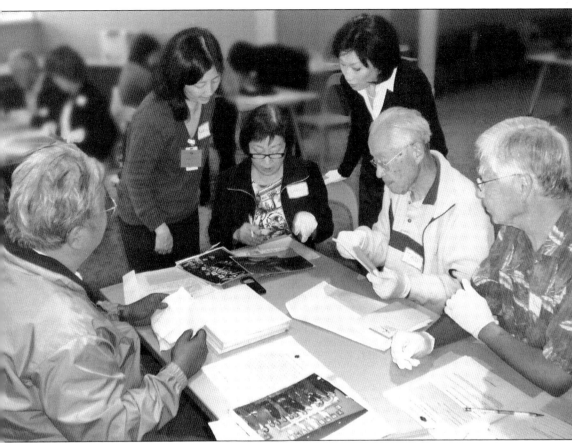

Members of the Little Tokyo Historical Society discuss photographs brought in by donors during their Community Photo Share Day held on December 5, 2009. Many of the photographs gathered at this event are included in this book. A wide-ranging group of persons interested in preserving Little Tokyo as a historic resource came together to form the Little Tokyo Historical Society (LTHS) in July 2006 under the sponsorship of the Little Tokyo Service Center (www.ltsc.org). LTHS is dedicated to discovering, preserving, and sharing the more than 125-year history of Little Tokyo in Los Angeles. The society records the varied and nuanced stories of people who have lived, visited, and worked in Little Tokyo, documenting the sites and events that have created this rich and colorful enclave. Projects by LTHS have included the successful nomination of the Aoyama Tree as a City of Los Angeles Historic-Cultural Monument, digital archiving of historic photographs and documents, street naming, history seminars, and this book, *Los Angeles's Little Tokyo*. For more information, visit their Web site at littletokyohs.org or e-mail lthistory@gmail.com. (Photograph and courtesy by Mike Murase.)

Discover Thousands of Local History Books
Featuring Millions of Vintage Images

Arcadia Publishing, the leading local history publisher in the United States, is committed to making history accessible and meaningful through publishing books that celebrate and preserve the heritage of America's people and places.

Find more books like this at
www.arcadiapublishing.com

Search for your hometown history, your old stomping grounds, and even your favorite sports team.

Consistent with our mission to preserve history on a local level, this book was printed in South Carolina on American-made paper and manufactured entirely in the United States. Products carrying the accredited Forest Stewardship Council (FSC) label are printed on 100 percent FSC-certified paper.